W9-DAI-774

VEILED HISTORIES

THE BODY, PLACE, AND PUBLIC ART

Anna Novakov, Editor

SAN FRANCISCO ART INSTITUTE
CRITICAL PRESS
New York, 1997

First Edition, Copyright © 1997
Published by Critical Press, the publishing arm of the Gunk Foundation, in conjunction with San Francisco Art Institute.

Compilation copyright © Critical Press, 1997.

All copyrights for the essays in this book are retained by the authors copyright © 1997, unless otherwise noted.

Statements of fact and opinion appearing in *Veiled Histories* are made on the responsibility of the authors alone, and do not imply the endorsement of the publisher.

All rights reserved. No part of this book may be reprinted or reproduced or utilized in any form or by any electronic, mechanical, or other means, now known or hereafter invented, including photocopying and recording, or in any information storage or retrieval system, without permission in writing from the publishers. Excerpts in reviews and scholarly articles (limited to 250 words) are permissible.

Every effort has been made to obtain permission to reproduce copyright material in this book. The publisher asks copyright holders to contact them if permission has inadvertently not been sought or if proper acknowledgment has not been made.

This book was published using QuarkXpress, and typeset using Gill Sans. It is printed on recycled paper. Designed by Peter Rutledge Koch assisted by Richard Seibert. Additional thanks to Christine Heun Design, Phil Underdown, and Michael Read.

Critical Press
PO Box 333
Gardiner, NY 12525
(914) 255-8252
gunk@mhv.net
http://www1.mhv.net/~gunk

The paper used in this publication meets the minimum requirements of American National Standard for Information Sciences—Permanence of Paper for Printed Library Materials, ANSI Z39.48-1984.

ISBN: 1883831-07-5
Library of Congress Catalog Card Number: 97-066969

For my daughter Christina.

Thinking Publicly:
The New Era of Public Art

Veiled Histories is the flagship book of The Gunk Foundation/Critical Press series *Thinking Publicly: The New Era of Public Art.*

As public space becomes saturated by corporate culture, a new generation of artists is emerging. Frustrated by the insulated art world, encouraged by the politicization of art in the 80s, and desirous of the rupture between high and low art, artists are looking into the space of everyday life to find a new canvas. The cement wall, the basketball court, and the bathroom stall have all been recent galleries for these artists. Public art, as it moves away from its traditional association with the bronze-man-on-horse statue, is rethinking some fundamental questions of the postmodern era: What is art? Who is the audience? Who is the artist? What is the message? Most importantly, artists working in the public realm are attempting to challenge corporate leverage on the production of knowledge and to reclaim public space as the site of political, social, and cultural thought.

In an attempt to understand this changing realm of art and thought, the book series *Thinking Publicly* will broach many of the crucial topics relating to this field. How do we define art, the public, the artist, the community? Who should make the decisions about public art? How does the meaning of art change when it is no longer sequestered in the museum/gallery/private home? *Thinking Publicly* intends to question the current market-dominated system of art production and to understand how the function of art transforms when it is moved out of the market and into the "public realm."

Nadine Lemmon
Michael Read
Series Editors

FOREWORD

Since 1871, the San Francisco Art Institute has sponsored, generated, and been the site of provocative dialogues concerning contemporary art. Our charter mandates not only a school for instruction in the fine arts but a commitment to the promotion of public understanding concerning that art. *Veiled Histories* is therefore a significant aspect of our history and part of a continuum that has engaged some of the leading artists, thinkers, and activists of their times in discussions about art, its sources, directions, purposes, and roles in society. As we celebrate the San Francisco Art Institute's 125th anniversary, we are especially honored to, once again, convene a truly distinguished group of artists and writers to examine multiple ways in which individual artistic activity can reveal, catalogue, provoke, connect, and frequently change the physical and social environments in which art participates.

The particular topic of *Veiled Histories* focused on the negotiation among literal, symbolic, and metaphorical bodies, is both a most vexing and compelling one to investigate at this moment. In recent years, we have seen the corporal bodies of many artists become terrain of the cultural war declared by political conservatives and the religious right. Simultaneously, the art of our times has been irrevocably altered by the presence of AIDS; a phenomenon that has introduced a heavily scatological intimacy into the common parlance and practice of the art world, while it has robbed the future of significant bodies of work that will never be created by the artists who have been afflicted. Heightened consciousness of cultural differences has made artists and art viewers alike alert to manifestations of specific physical and/or social bodies. Frequently today, an artist's body is not merely a romantic vessel through which the muses flow but a mediating presence, a text in itself, which has its own history and demands its own reading if an artist's work is to be thoroughly understood. For all of these reasons, the presence of the body or its evidence in the public realm is a rich emotionally and psychologically charged concern of artists and public alike.

The issues addressed in *Veiled Histories* are especially exciting to have been raised in an educational context such as the San Francisco Art Institute. Our pedagogical practice has always emphasized

the exploration of personal expression. As we approach the end of the twentieth century, postromanticism and even postmodernism, a great number of our students are increasingly interested in using that exploration in ways that will explicitly connect them with larger social contexts. The art works under consideration in *Veiled Histories* all reflect some of the most current activities in this arena of private/public engagement, dedicated to investigations of the ways in which artistic interventions can connect or in some ways disconnect us from each other. The boundaries of public and private, and the exchanges which take place across these delicate borders, are fertile territory for teaching art today. Because these borders are dynamic, with both artist and viewer being equal participants, this work represents a new model for students who wish to work in the area once insufficiently categorized as "public art." The San Francisco Art Institute is especially pleased to sponsor the variety of events and publications that together constitute *Veiled Histories,* to forward both the public understanding and individual artistic practice concerning the physical, emotional, and psychological presence of art in our lives.

I would like to thank Anna Novakov for her vision and determination in both conceiving and coordinating *Veiled Histories*. Extensive thanks are due to the writers and numerous participants in *Veiled Histories* events; it is an honor to share their work and thoughts. We are indebted to the ongoing support of the San Francisco Art Institute Board of Trustees, whose enthusiasm, hard work, and generosity have been so helpful, not only to *Veiled Histories* but to the continued flourishing of all the public programs that will distinguish the San Francisco Art Institute during its *next* 125 years.

Ella King Torrey, *President*
San Francisco Art Institute

CONTENTS

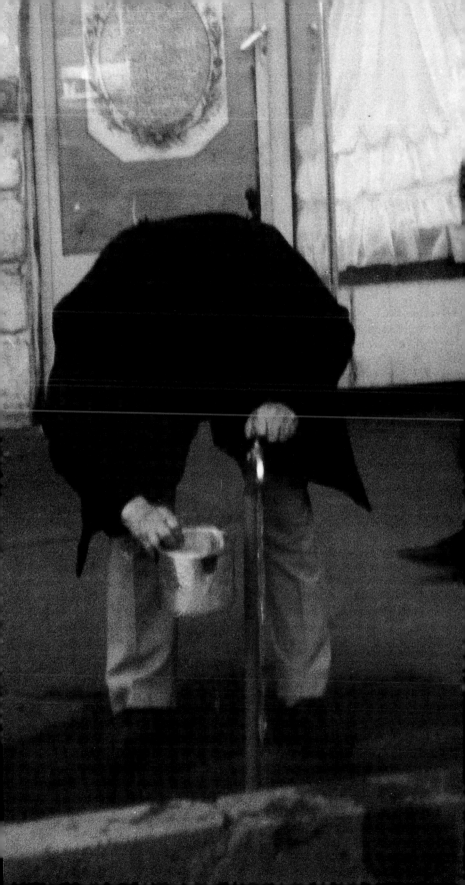

INTRODUCTION:
Locating the Private in the Public

Anna Novakov

On May 30, 1995, the *New York Times* published a photograph taken on the streets of Teheran. The photograph shows a man, bent over, facing the street, getting a drink of water. Behind him, two veiled women walk together on the sidewalk, passing a large storefront window that displays several white, Western wedding gowns. The storefront window opens out into the street, and the adjacent shop door provides access both into the store and onto the city street. The photograph (by Charles W. Holmes of Cox Newspapers) was coupled, in the California edition of the newspaper, with this caption: "Under the theocracy that rules Iran, there are many rules, and also ways around them. Women in traditional clothing passed wedding dresses in a Teheran store window." It is this photograph and its appearance in the newspaper that provoked the dialogue that would eventually evolve into *Veiled Histories*.

This newspaper photograph, when considered as a metaphor, brings up many issues that will be discussed (in other contexts) within the confines of this book. How is private space delimited from public space? If the personal body is the private space, then the *hajib*, or veil, becomes a thin membrane that divides the women's private bodies from the public space of the street that surrounds them. If the interior of the bridal store is a space for the acting out of private desires, then the shop window is the translucent layer that separates this space and the public space of the pedestrians on the street. This newspaper photograph also brings to mind issues of multiple narratives, or the layering of historical truths. If public history is constructed through the state, then at what point does personal history come into being? Perhaps personal history develops at the point of contact between the personal body and the social body — the translucent threshold of the window is the interface between these two parallel worlds.

The following texts address issues of the private and the public

3

and the creation of narratives through the insertion of the personal body into the surrounding urban, social body. These original texts and projects also bear witness to public interventions as key preoccupations for some of the most accomplished contemporary artists. Their texts have been situated so as to complement adjoining projects as well as force the formation of theoretical and conceptual spaces within which these projects are allowed to affect and reflect upon each other.

Projects by Marina Abramovic, Dennis Adams, Jochen Gerz, Suzanne Lacy, Victoria Vesna, Krzysztof Wodiczko, and myself approach history as a narrative that is essentially grounded in the personal body. Through unveiling the personal body, both physically and metaphorically, one is able to gain access to the historical constructions of the enveloping social body. The street is the arena for the playing out of this exchange. The artist working in the public space functions as a guide to this multilayered urban topography. Their work is the creation of an interface between the personal body and the construction of the historical narratives of the public body.

In my essay on Marina Abramovic's performance, *Role Exchange*, I have used the concept of the storefront as a way of exploring issues of display, desire, and the construction of the self through the personal history of another. Abramovic parallels her life with that of a prostitute working in Amsterdam as a way of establishing the parameters of herself as an artist and the other woman as a prostitute. This essay is coupled with a dialogue between myself and Abramovic in which I try to push the boundaries of my own inquiries about art as an art historian faced with the artist the subject of my inquiry. This verbal exchange is itself a type of role exchange, which results in a subtle shift of textual meaning between my interpretations of her work and her physical and psychological memories of the historical event that created it.

Dennis Adams in *Recovered/10 on 10 (Adams on Garanger)* "collaborates" with French documentary photographer Marc Garanger to create a series of ten limited edition books. Garanger, during the French-Algerian War, was assigned to take photographs, for control purposes, of Algerian women for the French government. He gathered 2,000 veiled women, one by one, removed their veils, photographed their faces, and replaced their veils. The photographs

became emblematic of cultural conflict as well as issues of gender and the violations of private space. Adams in his project reveils the women by blanketing them with his own photographs of contemporary Algerian public housing in Paris. The veil becomes reconstructed out of the historical developments of the original military conflict. The body is the basis for the construction of their identity as women and as displaced Algerians in a French urban structure.

Adams coupled *Recovered/10 on 10* with *10 thru 20/ Voices from The Hague* a project that he installed at Stroom, an exhibition space across the street from Richard Meier's City Hall in The Hague. The project consists of 11 video monitors displaying recent immigrants to the area talking about themselves and their position within the larger society that they now inhabit. The monitors present only the faces of the immigrants, while space is provided in front of the monitors to sit and listen to their stories. These decontextualized spaces are the transformed registration counters from the City Hall atrium. The immigrant's personal histories are recreated through the repetition of their stories on the monitors and through the space that is constructed between their narratives and those presented on the neighboring monitors. Their physical bodies are recreated through the exchange between the visitors and the monitors, which function as their surrogate bodies.

Jochen Gerz's work addresses issues of collective memory as narratives formed from individual physical memories. In the *Harburg Monument Against Fascism,* the public was asked to sign a columnar memorial to the Holocaust. Over time, the lead column was lowered into the ground, until finally after a year of inscriptions it became completely invisible, interred into the site. The signatures, which began as clear marks on the lead, over time, became so covered with text, cuts, slashes, and even bullet holes that reading individual entries became almost impossible. One narrative was shrouded and veiled by the next. Personal memory of the monument resides in writing, the inscription created through the physical body touching the lead. It is that bodily connection that allows the viewer to leap from the immediacy of the monument to the private memories that are elicited by the retelling of the events of the Holocaust.

Victoria Vesna's *Under Re-Construction: Architectures of Bodies©️ INCorporated* uses the Internet as a public space, which *anyone* can

enter using a computer and a modem. She has created a computer program in which anonymous people can "log on" and enter into a dialogue on the monitor. Through this dialogue and a system of commands, each person is able to alter the physical body of the other participants. The body is scanned onto the screen and can be altered to accommodate personal preferences, such as body type, hair and eye color, gender, and so on. Vesna's work bridges, through contemporary technology, the space between the personal body and the public body. At some point through the digital process the two aspire to become "virtually" indistinguishable.

An *Alien Staff* is a constructed apparatus through which Krzysztof Wodiczko explores issues of immigration, cultural displacement, and storytelling. He uses these compact structures as modems that transport narrative data from one person to the next. They are light, portable, and handheld. They require that the body of the storyteller be physically connected with the staff. The staff is a metaphorical as well as physical interface, which shifts the position of the immigrant speaker from a passive observer to an active participant in the creation of their own history.

In *Prostitution Notes,* Suzanne Lacy explores personal identity through a series of diaries and navigations into the spaces of sexual commerce. Lacy maps the spaces of sexual exchange in Los Angeles, interjecting herself as both an active and passive observer of the scene. Her project addresses the spaces that separate her personal history with that of the sex workers that she encounters. With the use of banal references to coffee shops or automobiles, she challenges and mystifies the issue of separate personal narratives and injects in its place a sense of the inability to contain our own story within the boundaries of the personal body. One body blends and mirrors another immediately upon contact, thus shifting personal history into public narrative.

The texts that comprise *Veiled Histories* fall into three literary forms: artist statement, interview, and essay. These forms were selected and intended to be read as part of a larger structure that permeates the book. In many ways the Teheran photograph sets up an armature for the direction and issues presented in the book. The physical structure of the book also uses the issues brought up in the photograph but does so in a much more "veiled" manner.

The artists' statements are the place for personal reflection and are in many ways the closest to the mind and body of the artists who wrote them. The interview format is the point of cooperative exchange between the artists and critics writing and thinking about their work. Through the interview process there is a necessary give and take between the personal reflections of the artist and the objective analysis of the critic. The third category of texts is the essay format, which attempts to achieve an objective, critical distance between the body of the artist, their work, and the body of the critic.

Individually, each of these narrative formats is constrained at the onset. The attempt to create a personal statement, truly interactive dialogue, or objective analysis is by nature a limited pursuit. Bearing this in mind, however, it was my belief that this combination of formats would provide a narrative system that would best embody the notion of multiple histories. The reading of these texts and accompanying images involves a process of continual shift, revelation, and reflection. The projects, of course, also function as clues in the construction of private memory, personal history, and the process of veiling and unveiling issues of the private and the public.

I am grateful to my colleagues at the San Francisco Art Institute, Rozanne Stringer, Larry Thomas, and Ella King Torrey, for their academic support of *Veiled Histories*. I would especially like to acknowledge my collaborators: Marina Abramovic, Dennis Adams, Jochen Gerz, Suzanne Lacy, Victoria Vesna, and Krzysztof Wodiczko for their professionalism and personal insights. Their participation in this project has been invaluable to me. I thank my husband, Rik Ritchey, for his clarity of vision, sensitive criticism, and unwavering support.

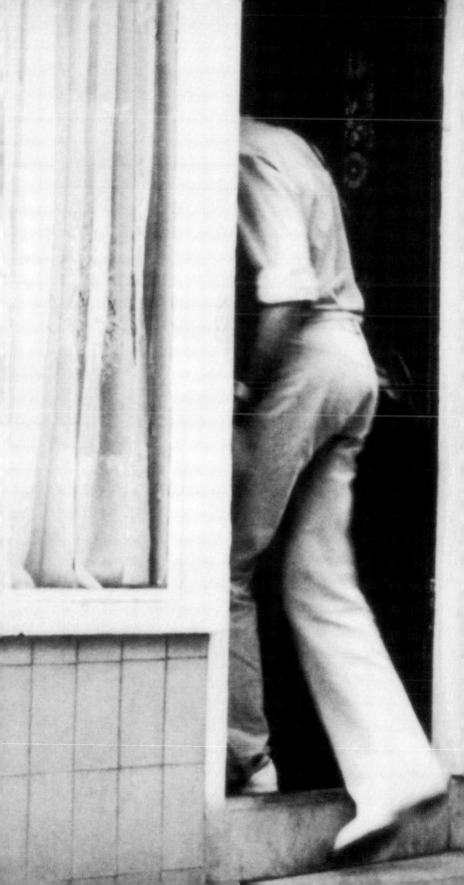

LA FILLE PUBLIQUE

Anna Novakov

How many irritations for the single woman! She can hardly ever go out in the evening; she would be taken for a prostitute. There are a thousand places where only men are to be seen, and if she needs to go there on business, the men are amazed, and laugh like fools… should she find herself delayed at the other end of Paris and hungry, she will not dare enter into a restaurant. She would constitute an event; she would be a spectacle. All eyes would be constantly fixed on her, and she would overhear uncomplimentary and bold conjectures.

— Jules Michelet, *La Femme* (1858–1860)[1]

…when they are caught between the hereditary moral impulse implanted by their parents and the tyrannical desire for a woman whom they ought to despise. Numerous and ignoble infidelities, habits which betray their evil haunts, shameful secrets unseasonably laid bare, inspire you with horror for your ideal, and it sometimes comes to pass that your joy makes you shudder. Here you are much embarrassed in your platonic reasonings. Virtue and Pride cry: Fly from her. Nature speaks in your ear: Whither can I fly? These are terrible alternatives, in face of which even the strongest souls reveal the insufficiency of all our philosophical education.

— Charles Baudelaire, *Intimate Journals* (1862)[2]

The topic of sexual commerce has been a preoccupation for many artists throughout the nineteenth and early twentieth centuries. Degas, Manet, Toulouse-Lautrec, Renoir, Atget, Kirchner, Brassai, Beckmann, Picasso — their names form a who's who of male modernist painters and photographers — all working with images of prostitutes, street walkers, or *les filles publique*. In the latter part of the twentieth century women artists, such as Annie Sprinkle in her 1989 performance, *Public Cervix*, and Merry Alpern in her 1994 photographic series, *Dirty Windows,* have employed sexual commerce as subject matter and as a result created provocative and engaging works that challenge contemporary notions of spectatorship,

desire, and display. In this essay I will be discussing a performance by artist Marina Abramovic in which she created an urban intervention that slipped elusively into the space between the public and the private arena.

In 1975, Abramovic staged *Role Exchange,* a work in which she befriended and ultimately collaborated with a prostitute in Amsterdam's red-light district. The prostitute had been actively working in the city for the past ten years; likewise, Abramovic had been working as a "professional" artist during that same time period. Over a span of four hours, Abramovic traded places with the prostitute and sat in her window in the red-light district while the prostitute went to de Appel, Abramovic's gallery, and impersonated her during a four-hour-long exhibition opening. Each performed all of her duties during these public spectacles, acting as each other's alter ego in a complex game of commercial and aesthetic exchange. Each was inside an enclosed space that was open and visible to the outside street through a large, framed picture window. One could also gain access to both spaces through doors that open out into the street as well as into the space of the gallery or brothel. In *Role Exchange,* Abramovic explored the uses of the window and the doorway as multilayered metaphors for the interface between public and private space, commerce and sexuality, the voyeur and the spectacle, the artist and the prostitute, the self and the other.

In *Role Exchange,* the window functions as a boundary between the world of the street, which has always been demarcated as the public world of men, and the enclosed world of the brothel, the semiprivate world of women, which men penetrate as a point of access to the realm of commercial desire. The brothels of Amsterdam are storefronts for the sale of carnal pleasure. Each storefront houses a particular type of fantasy woman who establishes her own scopophilic charade by reacting against and with the neighboring women, thus constructing a unique illusory sexual identity. Seen as a whole, the brothels form an elaborate commercial mall that markets itself as an exploration into the modalities of desire, ranging from symbolic embodiments of the youthful, virginal innocent to the mature, experienced matron. The passerby on the bustling Amsterdam street is able to gaze into the window and see Abramovic, as well as their own reflection in the glass.

12

The window functions as a form of transparent containment. It provides a reflexive division between the space of the interior and that of the exterior — a constantly fluctuating interface between the personal body and the social body. The picture window is employed as a framing device for the desires of the spectator and the spectacle. Seen as a frame around a painting, the window acts to isolate and delimit the erotic arena or the space of sexual fantasy. The picture window of the gallery similarly emphasizes the space of aesthetic containment, the venue for the playing out of visceral experiences. According to Le Courbusier, "a window is man himself…. The porte-fenetre provides man with a frame, it accords with his outlines…. The vertical is the line of the upright human being, it is the line of life itself."[3]

The picture window "turns the outside world into an image to be consumed by those inside the house, but it also displays the image of the interior to that outside world."[4] As a geographic marker, the window is crucial in the spectator's ability to identify and categorize the nature of the spectacle that they are witnessing. The window and doorway are the architectural reference points through which constructions of male and female sexuality are established, discussed, and ultimately dismantled.

Writing about forms of architectural enclosure, Beatriz Colomina states that windows act to establish the "radical difference between interior and exterior, reflecting the split between the intimate and the social life of the metropolitan being: 'outside,' the realm of exchange, money, and masks; 'inside,' the realm of the inalienable, the nonexchangeable, and the unspeakable. Moreover, this split between inside and outside, between the other senses and sight, is gender-loaded. The exterior of the house, [Adolph] Loos writes, should resemble a dinner jacket, a male mask, as the unified self, protected by a seamless facade, is masculine. The interior is the scene of sexuality and of reproduction, all the things that would divide the subject in the outside world."[5] This act of architectural categorization is important in the role that it plays in delimiting the nature of the spectator as well as the spectacle itself. The viewer is defined by that which they view. The reflection on the glass is an indication of a narcissistic involvement with the self and the self as a player in a complex sexual game. The view of the other is constructed through the establishment of

boundaries between ourselves and the world around us, whereby "the body is produced as spectacle, the object of an erotic gaze, an erotic system of looks."[6]

*Indeed woman is just a sign, a fiction, a confection of meanings and fantasies. Femininity is not the natural condition of female persons. It is a historically variable ideological construction of meaning for a sign W*O*M*A*N, which is produced by and for another social group, which derives its identity and imagined superiority by manufacturing the specter of this fantastic Other. WOMAN is both an idol and nothing but a word.*
— Griselda Pollock, "Modernity and the Spaces of Femininity"[7]

Doorways in *Role Exchange* are symbolic as well as literal passageways from the spaces of the exterior, the street, to that of the interior, the gallery and brothel. They are thresholds across which commerce is conducted. The nature of this commercial exchange is central to the demarcated intersections between public and private space. They are also central to the reinforcement of areas of containment used for the indulgence of erotic and aesthetic pleasure. Here, as in the case of the picture windows, you have a framed point of access from the narcissistic world of the self to the self-reflexive, constructed identity of the other. "Architecture is not simply a platform that accommodates the viewing subject. It is a viewing mechanism that produces the subject. It precedes and frames its occupant."[8]

I can feel myself under the gaze of someone whose eyes I do not even see, not even discern. All that is necessary is for something to signify to me that there may be others there. The window if it gets a bit dark and if I have reasons for thinking that there is someone behind it, is straightway a gaze. For the moment this gaze exists, I am already something other, in that I feel myself becoming an object for the gaze of others. But in this position, which is a reciprocal one, others also know that I am an object who knows himself to be seen.
— Jacques Lacan, "The Seminar of Jacques Lacan: Book I, Freud's Paper on Technique"[9]

Abramovic's performance reexamines modernist notions of viewer and spectacle and the relationships between men and women in the highly gendered spaces of the urban street as evidenced by paintings such as Manet's *Nana*, 1877, Degas's *Waiting for the Client*, 1879, and Picasso's *Les Demoiselles d'Avignon*, 1907. By reinvestigating nineteenth-

century ideas of the *flaneur* and *flaneuse,* Abramovic is able to infuse her work with a multifarious charge that slides it from the world of art to that of public spaces and the linguistic constructions of sexual frameworks. Walter Benjamin, godfather of urban thought, believed *flanerie* to be "a form of pedestrian connoisseurship and consumption of the urban environment."[10] The city, which was soon personified as a writhing den of sensual provocations, was something to be noted and textualized with the mind but not with the heart. As Arthur Rimbaud wrote:

> *You will close your eyes, so as not to see through the window*
> *The evening shadows grimacing*
> *Those snarling monsters, a swarm*
> *Of black devils and black wolves*[11]

Charles Baudelaire is today perhaps the most well known voice for mid-nineteenth-century thought related to the expanding urban experience. He described the *flaneur* in mid-nineteenth-century Paris as a kind of urban nomad who walked the teeming streets with a keen sense of sight and smell. The modern street became for him a sensory text that needed to be deciphered, read, and interpreted, from an objective and privileged position. In other words, the *flaneur* saw all but was not taken in by it.

> *The world of light flitted before the window prevented me from casting*
> *more than a glance upon each visage, still it seemed that, in my then*
> *peculiar mental state, I could frequently read, even in that brief interval of*
> *a glance, the history of long years.*
> — Edgar Allan Poe, "The Man of the Crowd"[12]

In the latter half of the nineteenth century, many women were beginning to be able to move in public spaces more than they had at any other historical point. Carriages started transporting them from their homes to various destinations around the city with some regularity. To overestimate the availability of urban space to women, however, is to place a contemporary interpretation on a society that certainly operated on a very different level than our own. According to many, the notion of the female *flaneur* or *flaneuse* is incongruous to the basic principles of *flanerie.* Émile Zola writes about the *flaneuse* in his book, *L'Assommoir:* "Then, trotting in the mud, splashed by coaches, blinded

by the resplendence of shop windows, she had longings that twisted in her stomach, like clothes, longing to be well set, to eat in restaurants, to go out to events, to have her own room with her own furniture. She stopped completely pale with desire, she felt rising along the length of her thighs a heat from the pavement of Paris, a ferocious appetite to bite into those pleasures that turned her upside down, there in the midst of the throng of the sidewalk."[13]

The term "streetwalker" is one that was coined contemporaneously with the word *flaneur*. While at first their meanings seem to be closely related, on a moral and ethical plane, however, they are perceived as the antithesis of each other. The *flaneur* is presented in literature and art as someone who is ultimately in charge of his body and desires while traversing the public space. The streetwalker, or *flaneuse*, is one consumed with desire, one that is by necessity unable to be contained within the confines of the home, or interior space. She is thought to inhabit the street because of her inability to master control over either her own body or the enveloping social body.

Janet Wolff writes, "In the nineteenth century, the *flaneuse* could never be simply the feminine pendant of the *flaneur*. A woman roaming the public spaces of the modern city was a *fille publique,* a lost woman, a prostitute working the streets in search of a client. The modern city was represented from a male point of view, as a leisure/spectacle society, where men were the customers and women the consumed in their roles as workers of the leisure industry barmaids, singers, dancers, acrobats, prostitutes, and so forth."[14] Baudelaire was well aware of the relationship between women, sexuality, and the spectacle when he wrote that "the courtesan ... is a creature of show, an object of public pleasure."[15] As a professional she performs behind glass; framed by the architectural structure of the spectacle, she allows herself to be engaged in the economic system, which by its nature is a bridge between the world of the interior, the home, and the exterior, the public. Her appearance in doorways and in windows acts as a visual metaphor for the commercial display of desire.

Discussions revolving around women and uncontrollable sexual desire are of course not new. This avenue of discourse has existed in some form, certainly, since the Greeks and has continued to evolve ever since. During the Renaissance numerous bizarre stories were written about women who ventured into the arena of moral danger

posed by public space. According to Lynn Hunt in her book, *The Invention of Pornography,* "Girolamo Morlini's pornographic *Novellae* (1520), for example, recounted the story of a woman who was so moved by the sight of a statue with an erect penis (*erectus ille priapus*) in a public square, that she conceived of the desire to kiss it. When flesh touched stone, she succumbed to the temptation to copulate, enjoying the pleasures of the statue until dawn ... While the sixteenth century had placed such images within the discourse of the arts, the seventeenth century understood them to be potentially blasphemous. Morlini's playful tale, an object of Renaissance mirth, was now a matter of public morality."[16] This need to protect women from themselves and from the gaze of the spectator is at the root of much global thought on gender relations, from laws punishing adultery by imprisonment or death to dogmatic theories on veiling and architectural containment. What is perhaps specific to the modern and subsequent postmodern era is the direct articulation of the relationship between the spectator and the spectacle, the *flaneur* and the object of his gaze.

In the 1960s, the concept of the public spectacle was brought to the forefront by the seminal work of Guy Debord and the Situationists. *The Society of the Spectacle* laid the groundwork for much contemporary discourse on public art and urban theory. The evolving notions of the spectator and the spectacle also form the basis for a substantial amount of feminist thought that has employed these concepts as ways of exploring issues of domination and patriarchy, which are perceived as symptomatic of the male gaze in the city.

The "painted woman," or prostitute, is "emblematic of the collapse of the opposition between sex and work. Her labor is the selling of sexuality." Sigmund Freud, in *Civilization and Its Discontents,* writes about "the significance of work for the economics of the libido," noting that "no other technique for the conduct of life attaches the individual so firmly to reality as laying emphasis on work The possibility it offers of displacing a large amount of libidinal components, whether narcissistic, aggressive or even erotic, on to professional work and on to the human relations connected with it lends it a value by no means second to what it enjoys as something indispensable to the preservation and justification of existence in society."[17] For Freud and many other modernist thinkers, it is the interconnection between the world of commerce and the world of sexuality as discussed

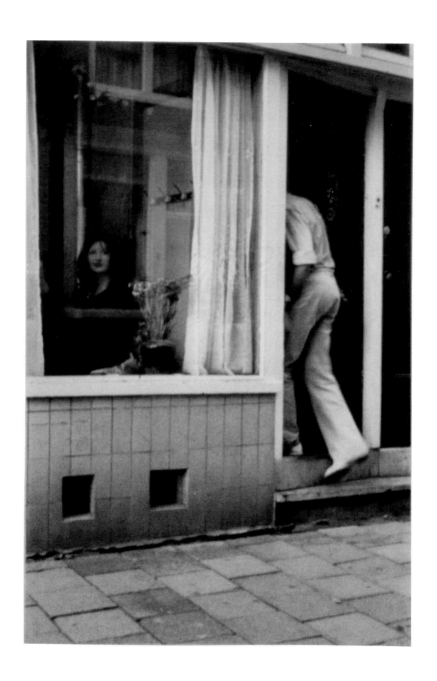

earlier, the establishment of spaces of transaction marked by the window and the doorway that is most problematic to the society at large.

Abramovic's public performance uses the framed window and doorway motif as sensual points of access, visual metaphors for the spaces of scopophilia as well as commercial transaction. The corruption of the social body is ultimately viewed through the lens of rampant capitalism and a booming economy. Artists are pure until tainted by the sale of their work. The woman is chaste until desire meets with action, or sexuality with work and in turn money. In the writings of Walter Benjamin, the window is significant as it relates to the structures of the shopping arcades, and it is also indicative of the point at which the "city is metamorphosed into an interior."[18] Female desire, as it is personified by the department store, indicates that women start entering into the arena of the street and by doing so they begin to dismantle *flanerie,* a system that is based on the oppositional balance between the spectator and the spectacle an abstract equation that is kept intact by never being directly engaged. According to Priscilla Ferguson, "When *flanerie* moves into the private realm of the department store, feminization alters this urban practice almost beyond recognition and jeopardizes, when it does not altogether obliterate, the identification of *flaneur* and artist."[19] "Women, it is claimed, compromise the detachment that distinguishes the true *flaneur.* In other words, women shop, and today, as in the early nineteenth century when the arcades first make shopping a new, exciting and specifically urban practice and pleasure, shopping is invariably considered a female pursuit. Indeed, for these texts on *flanerie,* shopping seems to be the strongest social marker of female activity.... No woman is able to attain the aesthetic distance so crucial to the *flaneur's* superiority. She is unfit for *flanerie* because she desires the objects spread before her and acts upon that desire. The *flaneur,* on the other hand, desires the city as a whole, not a particular part of it." It is then, this feminization of the urban center that is seen as its ultimate demise. "The other" has entered into the privileged zone of established bourgeois space and "contaminated the social body."[20]

The bridge that Abramovic spans between the world of art and that of prostitution is illuminated by the use of the window and doorway as architectural metaphors, and it is also discussed within the very nature of our understanding of the linguistic connection between the two words "artist" and "prostitute." According to Webster's dictionary "prostitute" means: "v. *1. to sell the services of (oneself or another) for*

purposes of sexual intercourse. 2. to sell (oneself, one's artistic or moral integrity) for low or unworthy purposes; debased, corrupt. n.1. a woman who engages in promiscuous sexual intercourse for pay; whore, harlot. 2. a person, as a writer, artist, who sells his services for low or unworthy purposes." The second definition is an obvious reference to this conflation of opposites embodied in the *flaneur*/artist/writer and the *flaneuse*/prostitute.

The textual references to *flanerie* are important as they relate to sight and to the contextualization of thought. The role of the *flaneur,* to a great extent, was to act as a societal intermediary, translating texts between the world of the safe domestic space and the dangerous public arena. Assuming the guise of an artist or poet, he could stroll through the new urban megalopolis, look through the windows, enter into the spaces of commercial transaction, and yet be able to interpret what he sees with the cunning impassivity of a kind of aberrant journalist. The street as it represented the microcosm of the body of the city was a teeming swarm of crowds, a melange of the privileged and the "unde-sirables." By nature, it was also an area of potential moral decay brought to it by immigrants, commerce, and prostitutes, or *les filles publique.* As Nietzsche wrote, "the threat of the swarm and the threat of individual desire are the same threat; the swarm's collective desire masks the desire of the individual."[21] The *flaneur* was the navigator through these torrid waters, an intermediary between the world of moral corruption and the public good. The *flaneuse,* on the other hand, inhabited the region "at the intersection of the visible and the invisible, women are placed as the guardians of the unspeakable."[22]

Abramovic in *Role Exchange* creates a new urban creature a hybrid that melds the *flaneur* and the *flaneuse* into a persona that is able to witness and engage, dominate and subordinate, and through this axial structure, create a new system of sexual identity. This public artist has evolved from the nineteenth-century passive observer into the late-twentieth-century urban, sexually savvy nomad. Through a conflation of traditional gender oppositions, as well as the merging of the roles of viewer and spectator, consumer and object of desire, she has succeed-ed in constructing and reconstructing thresholds of transaction that challenge dominant systems of corporal geography and attempt to rearticulate new arenas of public space. The window and the doorway are no longer ready-made constructs; rather they are self-reflective frameworks upon which one is allowed to hang layers of individual significance.

1. Griselda Pollock quoting Jules Michelet's novel, *La Femme*, in "Modernity and the Spaces of Femininity" in Norma Broude and Mary Garrard, eds., *The Expanding Discourse: Feminism and Art History* (New York: Harper Collins, 1992), 254.
2. Charles Baudelaire, *Intimate Journals*, translated by Christopher Isherwood (San Francisco: City Lights Books, 1983), 113.
3. Beatriz Colomina quoting Le Courbusier in *Almanach d'architecture moderne* (Editions Cres: Paris, 1925), in *Privacy and Publicity: Modern Architecture as Mass Media* (Cambridge: MIT Press, 1994), 134.
4. Ibid., Colomina, 8.
5. Ibid., Colomina, 274.
6. Ibid., Colomina, 281.
7. Pollock, "Modernity and the Spaces of Femininity," 255.
8. Beatriz Colomina, "The Split Wall: Domestic Voyeurism" in *Sexuality and Space* (Princeton: Princeton Papers on Architecture, 1992), 83.
9. Jacques Lacan, *The Seminar of Jacques Lacan: Book I, Freud's Paper on Technique, 1953–1954*, Jacques-Alain Miller ed., (New York and London: W.W. Norton and Co, 1988), 215.
10. Rob Shields, "Fancy Footwork: Walter Benjamin's Notes on Flanerie" in Keith Tester, ed., *The Flaneur* (London: Routledge Press, 1994), 61.
11. Kristin Ross quoting Arthur Rimbuad in *The Emergence of Social Space: Rimbaud and the Paris Commune* (Minneapolis: University of Minnesota Press, 1988), 34.
12. Edgar Allan Poe, "The Man of the Crowd" in *Great Tales and Poems of Edgar Allan Poe* (New York: Pocket Books, 1976), 324.
13. Hollis Clayson quoting Émile Zola in *L'Assommoir* in *Painted Love: Prostitution in French Art of the Impressionist Era* (New Haven: Yale University Press, 1991), 60.
14. Janet Wolff, *The Power of the City: The City of Power* (New York: Whitney Museum of American Art, 1992), 47.
15. Ruth Iskin quoting Charles Baudelaire in "Selling, Seduction, and Soliciting the Eye: Monet's Bar at the Folies-Bergère," *The Art Bulletin* (March 1995): 32.
16. Lynn Hunt, ed. *The Invention of Pornography: Obscenity and the Origins of Modernity, 1500–1800* (New York: Zone Books, 1993), 60.
17. Mary Ann Douane quoting Sigmund Freud's *Civilization and Its Discontents* in *Femmes Fatales: Feminism, Film Theory, Psychoanalysis* (New York: Routledge, 1991), 259–260.
18. Ross, *The Emergence of Social Space*, 38.
19. Priscilla Parkhurst Ferguson, "The Flaneur On and Off the Streets of Paris" in Keith Tester, ed., *The Flaneur* (London: Routledge Press, 1994), 23.
20. Ross, *The Emergence of Social Space*, 27.
21. Ibid., Ross, 100.
22. Laura Mulvey, "Melodrama Inside and Outside the Home" quoted in Colomina, *Privacy and Publicity*, 248.

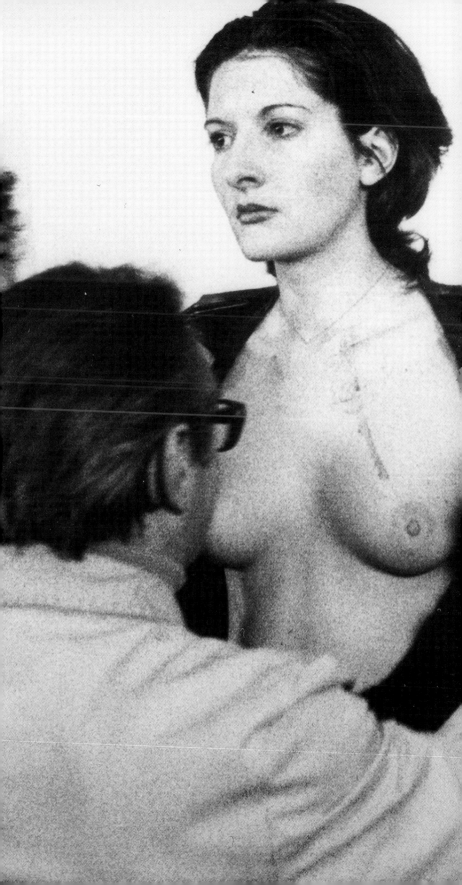

ROLE EXCHANGE:
Desire, Beauty, and the Public

Marina Abramovic
in conversation with *Anna Novakov*

I find a woman who has worked as a professional prostitute to ten years.
At this point I have also worked as an artist for ten years.
I propose to exchange roles.
She accepts.
She replaces me at my opening at De Appel Gallery in Amsterdam.
At the same time I sit in her place in a window of the red light district in Amsterdam.
We both take total responsibility for our roles.

Duration: 4 hours
1975
De Appel Gallery
Red-light district
Amsterdam

MARINA ABRAMOVIC: In 1975, I was living in Yugoslavia and was invited to do a performance for a project called *Body Art*. That was the first time that I had been to Amsterdam and the first time that I had seen the red-light district. I found it to be quite shocking. Especially, coming from a communist/socialist country and having the background that I had. My mother was a major in the army. My father left when I was seventeen. My mother had to raise the children completely alone. She was very strict, always talking about morals, what was right and what was wrong.

Seeing the red-light district, I thought, what would happen if we were to exchange places, this woman who was a prostitute for ten years, with myself who was a professional artist for ten years; To really exchange roles, where she would be me and I would be her? I was very afraid, and every time that I am afraid of something, I know it's something important: how to take myself with all this ego that I had built up and then to become nobody. I was interested in the idea of being at the lowest social level, the prostitute. It involved, for me, a great deal of mental pressure. Physically it wasn't nearly as difficult an idea as it was mentally.

It took three months to find the right woman. It was fascinating to meet the people in the district. No one wanted to accept the situation because she had to clear it with the pimp who was controlling her area. Finally, I found a pimp who gave his woman permission to work with me. She was, in fact, his wife. In the beginning she was as afraid to come into the gallery as I was to sit in her window. Then I proposed to her that we divide the money from the performance equally, a total of about $300 dollars, $150 each for the four hours of work.

I was interested in the idea of the windows and the brothel spaces themselves as well as the moral aspects of the architectural space. I was sitting there with everyone looking at me, violently crushing my ego down to zero.

The brothels have the appearance of military spaces. Everything is utilitarian. Every object has a function, such as prophylactics, towels, Kleenex, water, and a small, very uncomfortable bed. Everything is geared toward work, and there is nothing pleasurable about it.

In the gallery during the opening, there was a camera showing my situation and a camera showing her situation. My camera was hidden; hers was visible. I didn't want anyone to know where I was. I wanted to blend into the environment. In my case, three men came in. The first one wanted to touch me and that was it. The second one wanted to talk, and the third one was looking for the prostitute herself.

After the performance, there was a double screening of the films. After seeing it, the prostitute said that I would starve to death in her job. I said, "Why, what did I do wrong?" and she responded, "Everything." Apparently there are two mirrors, one on either side of the window, so that you can see the customer coming before he is able to see you. If a man comes down the street who is very small, shy, or old, then you have to look very trusting, very sympathetic. If a strong, macho man comes along, you have to be very sexy and inviting. You have to play the role, and I was just sitting there not moving, hypnotized with fear. *Role Exchange* was an exploration into what happens if you totally exchange one situation for another. It is actually one of the hardest performances that I have ever done.

ANNA NOVAKOV: The window can be seen as both an architectural frame and as a metaphorical structure. How did you conceive of it? Could you see your own reflection as well as the street outside? Did you perceive it as a barrier between your space and the space of the street?

ABRAMOVIC: First of all, the streets are very narrow. You have a strong feeling of people continuously passing in front of you in the street. The window is not a barrier. You are instead very vulnerable there. It is an open situation. No reflection from the window comes into your space.

NOVAKOV: Did you get any critical response to the project at the time of the performance, or was it documented later in the press?

ABRAMOVIC: At the time, there were things that came out in the popular press, along the lines of "That crazy artist!" Much later, quite a few feminist writers took this piece as an example in their work. There was one German critic that I remember in particular who wanted to interview not only me but the prostitute as well, and so we went together.

The prostitute considered herself a kind of social worker. Most men do not come for fucking; they come for talking, for companionship. I got to know her quite well during the course of this project. I would go to their house for dinner where it was obvious that they really considered it just work, and yet he had three other women and was obviously a real pimp. They had been married for twenty years and had two children that they were taking care of in the countryside on weekends. During the week, she would invite me to come and have coffee with her. She said if you see the curtain closed, that means that she's working and that I should wait outside. When she was finished, we would have coffee before she had to go back to work. It was a real division between the body and mind. She was not affected by what she was doing.

NOVAKOV: One of the areas that I find particularly interesting and that I would like to talk with you about is your body works projects and the relationship that you see between your body, physical

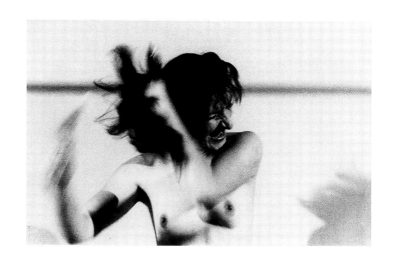

desire in general, and specifically the desire of the viewer toward you. What is the nature of the relationship that you establish between the viewer and yourself when you are performing?

ABRAMOVIC: This is an amazing question that I have never been asked before. I think that performing is about the creation of a construction, the removal of the ordinary self and the insertion of the metaphor. Whatever happens to you, you are in turn transmitting. You become a space, a space in which the public can project onto the body. It is very clear in *Rhythm O* [performed at the Gallery Studio Morra in Naples, 1975] that I am an object and anyone can do what they want with me. In Naples, the woman's body is clearly divided into three parts. The image of the mother, the image of the Madonna, and the image of the whore: Three classical projections. In my performances, I become a kind of anti-self in order to create room for the public space. There is desire, but I am not affected by it. It is similar to being in a meditative state for Tibetan monks, so that if you really concentrate, then you can leap into a higher self. It is through that leap that you are transformed into a mirror for the public's projections, so that whatever is projected onto you, desire, fear of death, whatever, you can react against by simply jumping into this higher self.

NOVAKOV: Who is defining the space between yourself and the public? Does the public establish the distance that is constructed between you and them?

ABRAMOVIC: I think that I define this space, and this is something that I actually feel. I am very conscious of how much freedom I can give to that public energy, and yet if you don't make this space available, the public has no way to engage the work.

NOVAKOV: How much of the performances do you plan beforehand? Is there a kind of outline of events that you follow?

ABRAMOVIC: Sometimes the planning happens a day before; sometimes only moments. It occasionally happens that I don't have an idea for a long time, and then it suddenly comes. There are other

types of performances that are more like theater, where you have to plan out a great deal. In general you have to establish a trust. You have to trust that if you invite me, something will happen. I love the way that ideas surprise me, when I'm on my way to the kitchen, chopping garlic, in the bathroom, wherever.

NOVAKOV: How does the architecture of the space that you are working in affect the work?

ABRAMOVIC: It is very important. In the early pieces, especially the work with Ulay, the architecture contributed greatly to what was really very minimal work. There is a strong relationship between the body and the space. You first look at the space and then at the bodies.

In performances you have either the chosen space, or the given space. With the given space or the chosen space you build the piece around the architectural space. Everything has to do with this space, including titles such as *Interruption in Space* or *Expansion in Space*. Everything is related to the body in space.

NOVAKOV: *Art Must Be Beautiful, Artist Must Be Beautiful*, performed at the Art Festival in Copenhagen, was another project done in 1975.

ABRAMOVIC: This piece was done before *Role Exchange*. It was in reaction to a lot of discussions about the relationship between art and beauty, or what is beautiful and what is not. Doing body art, I am simultaneously the artist and the object. I can create and destroy the object at the same time.

In *Art Must Be Beautiful, Artist Must Be Beautiful,* I started brushing my hair while asking the question over and over again. I started doing it slowly and thought of the audience as a mirror. I was look-ing at the mirror, then I started to brush my hair very violently and it progressed from there. I began brushing my face at the same time, scratching it, destroying it. First I created something, and through repetition, I destroyed it. I was very interested at that time in the subject and object of beauty.

32

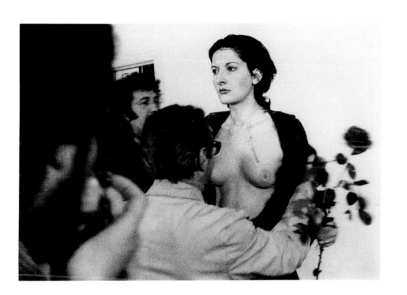

NOVAKOV: How do you think of beauty in terms of body art, or more specifically your own body as the object of other people's gaze? The object of the viewer's desire?

ABRAMOVIC: For a long period of my life, I was insecure about my appearance. It was when I met Ulay that I began to change the way that I dress and represent myself. Before that I used to dress in a very severe, manly way. I always thought that I had to be strong. Short hair, male clothes. With him I was able to change and in many ways become more feminine. I was the female element of the relationship. When he left, I became very insecure. I was forty years old, and left at zero. I was devastated and felt very ugly. Eventually that changed, and I realized that I loved fashion, kitsch, cake. I loved the whole idea of getting fat and then dieting. I loved my feminine side. In *Biography*, I really came into my own with that body/mind split; I came out and said "I am Marina Abramovic." I accepted glamour as a part of my image with my other side being heroic and shocking to the public. I am the marriage of these aspects.

NOVAKOV: In terms of the relationship that exists with the public, there seems to be a distinct difference between the work that you have done alone and the work that you have done with Ulay. In the collaborative work you appear to interact with the public less and to in fact become the object of a spectacle, the object of voyeurism.

ABRAMOVIC: We have talked about the employment of metaphor, the male and female relationship, of which separation is also an important part. I wanted to show that difference between us, in dress and in look. Ulay and I even had different press conferences, different dinners, different openings. There was a distance between myself, Ulay, and the third element, which is the public. Everyone experiences relationships. When he left, I turned again to the public. The removal of Ulay provided a much more complex space, a much more direct relationship between myself and the public.

NOVAKOV: How do you see objects, like the ones in the back of the brothel, functioning within your greater body of work? What kind of resonance do they have? Do they also perform? What is their relationship to aesthetics versus utilitarianism?

ABRAMOVIC: I see the objects, basically, as props, something to trigger the mind or the experience. They are a different strategy. They do not serve a decorative function. They are just tools. They are like a tray in a dressing room, very simple and very functional. Direct materials, such as iron, copper, quartz, and clay are meant to transport you somewhere. The object and the architecture, the wall, oftentimes, become a tool for the public. Every object is there for a function, not as decoration in any way. People only criticize this work when they haven't experienced it. You have to be sympathetic to it, to try it, to experience it. You have to try it out to see if it works: the right size, the right shape. With use it is transformed into a table, a bed, something that works. The experience is more important than anything else. When you only look and do not experience, then you stay only on the aesthetic level. Once you experience it, you jump to a higher level, to a different plane.

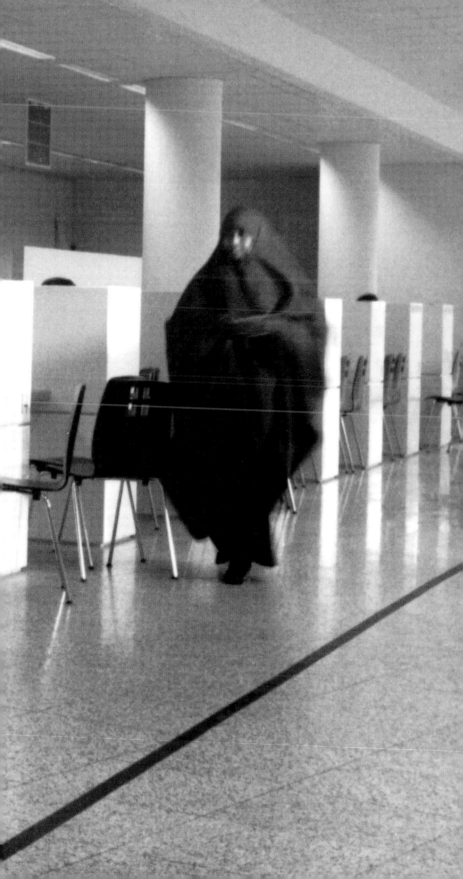

10 thru 20

Voices from the Hague

Dennis Adams

10

On September 8, 1995, Richard Meier's new City Hall/Library complex officially opened in the Spui district of the Hague. Promoted as the symbolic forum of a new city center, "a public heart for the Hague," this massive urban monument, surfaced with Meier's signature grided white cladding, is the largest project designed by this American architect. Representative of a new structuring of urban functions, this complex brings together under one roof both civic and commercial domains that include council chambers and offices, a central public library and retail outlets. The concept of its design was developed as a direct response to the given urban fabric that surrounds the site, absorbing and mediating its formal complexities and contradictions through both plan and section.

11

At the center of this complex is a wedge shaped, glass roofed atrium of immense proportions that is both the physical and symbolic matrix of the architecture. In fact, it is the largest covered plaza in Europe, a new scale of "public space" in which open staircases, exposed walkways and glass elevators traverse its dimensions as stations for both viewing and being viewed. The subject of this volume is nothing less than "visibility" itself, generated through the reflection of natural light off of its vast white interior surfaces. Both Meier and his supporters have made claim for this "visibility" in the strictest of modernist ideals: the postulation of a democratic space that belongs to everyone, a sign of openness in waiting for new and yet undefined community formations.

12

In the spring of 1995, I was invited by Lily van Ginneken, the director of Stroom HCBK to visit the Hague and develop a project in relation to the city. Located across the street from Meier's new City Hall/ Library complex, Stroom is a cultural center that focuses on the intersection between art and public space. Artists are invited to produce public projects and/or develop installations for their exhibition space that specifically address the context of the Hague. During my first visit to the city, Meier's new building was in its final construction phase, scheduled to open in September of 1995. Models and drawings were on display at the city's information center and propaganda brochures were being distributed at various locations. Even in its unfinished state, the sheer scale and whiteness of the building's shell had already become an invasive sign in the surrounding urban network. It was in response to this critical window of reception that accompanies every new major work of architecture, that I decided to situate my intervention. The timing was perfect.

13

By my second trip at the end of September, the building had officially opened and its full reception was on the front burner of every conversation. During my first walk through the massive interior of the atrium, I was immediately struck by its built-in furnishings: 24 numbered registration stations that are used for various civic procedures, including immigrant registration, naturalization, voting registration and so forth. These reception niches were designed by Meier as an extension of his stark white geometric scheme. Their structure consists of a long wooden counter, partitioned into individual transaction zones by numbered white rectangular modules. Each station can accommodate two related patrons situated across the counter from the receiving public official. The patrons chairs are black painted versions of the natural wooden chairs that were specifically selected for the public areas of the interior spaces. Both types exist throughout the building and are punctuated by an identical grid of four squares that Meier had cut into the back of each chair as a kind of logo for the interior spaces at large.

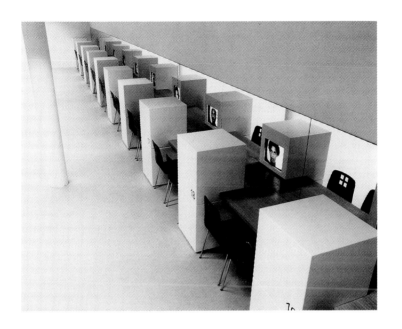

14

What is startling about these registration stations in relation to the atrium is their complete openness to public scrutiny. Both the applicants and public officials are in full view and can be easily overheard by others waiting to use the stations or people just passing through the atrium. This paranoiac aspect is compounded by the immense scale of the atrium in relation to the low and intimate elevation of the stations. Meier has promoted these open registration zones as a sign of democratic ideals. He resisted the use of bullet-proof glass that was demanded by a number of the buildings advisory committees for control purposes, insisting on closing the distance between the public official, the patron and the casual passersby.

15

For my project (10 thru 20), 24 registration stations were reconstructed inside the exhibition space of Stroom. Every detail of Meier's design was carefully duplicated in its exact scale. It was my intention to dislodge these furnishings from their bureaucratic function, transforming them into a forum for recent immigrants to the Hague. I was thinking of a platform for unofficial speech with the potential for dissent. To facilitate this, a video monitor was built into the backside of each of the eleven numbered partitions that separate the registration stations. Each monitor displays the face of a recent immigrant speaking about the problematic of his or her transition to the Hague. These monitors face away from the audience. They can only be viewed through their reflection in a mirrored wall that defines the rear boundary of the installation, displacing the space that the public official would normally occupy on the other side of the registration counter. It is congruent with the marginal status of immigrants that their images were positioned between the registration stations, literally on the edge of these official public furnishings. "Marginality" is demonstrated as a position of critical perception.

16

Only immigrants between the ages of 25 and 35 that had work experience in both their country of origin and the Hague were selected to speak. Individuals that immigrated directly from their

parents' home were not included. It was important for their critical facility that they had been economically independent in both their country of origin and the Hague. The video sessions were shot over a 30 minute time frame. I asked each person to speak for approximately five minutes and the rest of the time they were to remain silent. They were cued when to speak, but were allowed to finish their story within its natural time frame. Their stories were completely their own and were unrehearsed and undirected. Each person was alone in the room with the camera. There was not even a technical authority present.

17

In the wake of the installation's presence, what these immigrants had to say was perhaps not as important as their opportunity to say it. And then, there was this long, seemingly endless silence that really became the subject of the tapes. Immigrants are conventionally silenced both by their language disability and their prejudicial reception by the native population. So on the one hand, it was important to give them the opportunity to speak, but on the other hand, I was interested in how the magnification of that silencing might be reconstituted as a psychological weapon of dissent. At any one time, anywhere from one to five people were talking and of the rest of the eleven were silent. So there was also this perception that they had become each other's audience.

18

There were some who felt that 10 THRU 20 would have been more effective as an intervention, situated directly inside Meier's Atrium. In part, this response is probably conditioned on what is expected from one of my projects. And I would have to agree, that on a political level a good case can be made for it. However, I chose to reconstruct the registration counters inside the Stroom exhibition space, so they could connect through memory rather than direct comparison. In this way, they are clearly excerpted, not displaced, like a quote stolen from its context. They function as an image and not as a mistaken identity. This isolation allows for a more concentrated reading. A one to one relationship is set up between the viewer and the object. There is the possibility of being

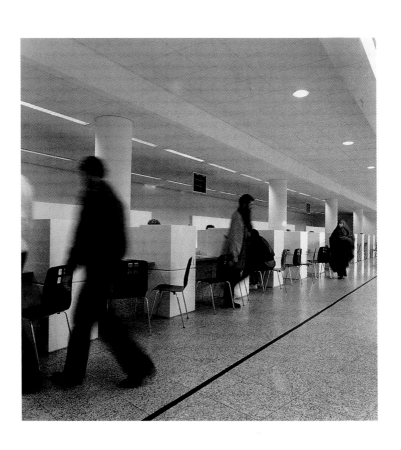

alone with this public furniture, of perhaps seeing it for the first time and meditating on the implications of its architecture with its reconfigured elements outside of the complexity of its context.

19

As an extension of this shift from the atrium to the exhibition space, there was a demonstrated equivalence between the two geometric white spaces. They share the same modernist genealogy. For some of my audience it was shocking to see how well Meier's furnishings adapted to their new context. Ironically, even the white columns of the exhibition space echoed Meier's own.

20

Compounded with their decontextualization from the atrium, the interfacing of the video portraits with Meier's registration stations gave the installation the connotation of an off-stage dressing room. Both the addition of the mirrored wall and the allusion to side-bar lighting created by the placement of the video monitors in the margins of each transaction niche, gave the visual impression of a row of theatrical make-up vanities. Typically these furnishings are found back stage and represent a station between the private world of the performer and his or her public persona. They mark the existential boundary of masquerade, as sites where public faces are applied and removed, accompanied by sound mixes of fictional voices and dialogues with the self. With its brightly illuminated performative arena and seating, the make-up vanity simulates the theater itself in condensed scale. The time and space between action and reaction, performer and audience is short circuited, compressed into a single reflected image on its mirrored glass. Structurally, it would seem that these furnishings occupy the zones of prologue and epilogue, but their relationship to narrative is more volatile and disturbed. Nothing is introduced, no conclusions drawn. Rather, they are platforms for endless rehearsals and recountings, where self doubt secures itself as the very subject of public transaction.

This text by Dennis Adams began as an interview with Hans Oerlemans, entitled "The Other American" and was published in *10 THRU 20*, a catalogue that accompanied the exhibition of the same name at Stroom HCBK in the Hague, 1995/96.

RECOVERED

10 on 10
(Adams on Garanger)
Editions Les Maîtres de Forme Contemporains,
Michèle Didier, Brussels, 1993

Dennis Adams

Each of these ten books re-presents on its (vertically extended) inside back cover a different portrait of an Algerian woman taken by photo-journalist Marc Garanger in 1960, when he was in the French military service in Algeria. These examples were selected from over 2000 portraits that were ordered by military authorities as identification documents for civilian control purposes. The majority of these photographs were taken of women, all of whom were forced to remove their veils.

In response to the inherent violence of this photographic act, the lower portions of these women's faces have been "re-covered" with ten pages of my own photographs documenting social housing projects on the outskirts of various French cities. Today, many of these decaying Modernist housing projects are the principle resi-dences of Algerian immigrants, signifying the culmination of France's long and turbulent history with its former colony.

This project was most recently exhibited in conjunction with 10 THRU 20/ Voices from the Hague at Stroom HCBK in the Hague, 1995-96.

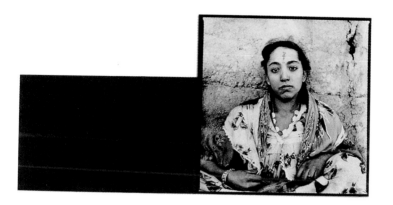

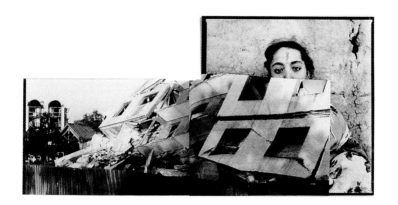

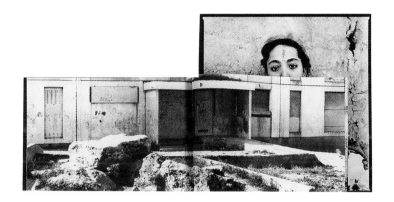

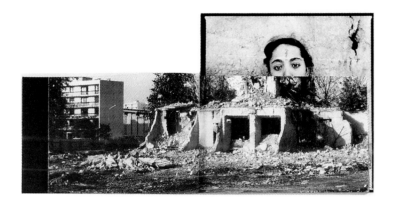

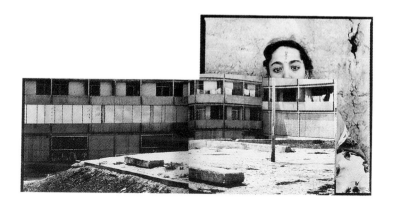

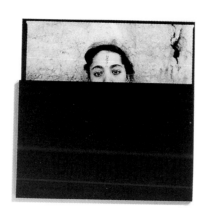

INVISIBLE MONUMENT

Jochen Gerz
in conversation with *Jacqueline Lichtenstein*
and *Gerard Wajeman*

In 1990 Jochen Gerz undertook a clandestine work of art, an invisible monument against racism. With the help of students from the fine-arts school, Gerz began nightly to take up various paving stones in the square in front of Saarbrucken Castle, a former Gestapo headquarters, and inscribe each stone with the name of a Jewish cemetery in Germany, before replacing them, inscribed name face down. After a heated debate in the Saarland parliament, the *Monument Against Racism* enjoyed an official inauguration.

JACQUELINE LICHTENSTEIN/GERARD WAJEMAN: This is not the first time that your work has touched upon the theme of invisibility, or the meaning and political effect of invisibility. In 1986 you worked on a piece in collaboration with Esther Shalev-Gerz in Harburg a monument against fascism that, although still partly visible today, is destined to disappear in the near future. This piece consists of a column standing ten meters high and divided into square sections (1 x 1 m), the whole of which is covered with a layer of lead. Passers-by are invited to engrave their signature into the lead column, which descends progressively as the surface available for new signature becomes filled up. In the end, once the final signature has been inscribed, the monument will have disappeared altogether. Does the latest monument in Saarbrucken stand in relation to the earlier Harburg monument?

JOCHEN GERZ: The Harburg monument is the result of a slightly different project. It is as if we had installed a work by Mark Tobey in a public place, allowing just anybody to come along and leave their mark on it, or even hack it to pieces. In addition to this, I think that the reactions of many people were affected by the taboo existing in contemporary Germany surrounding the notion of traces, physical marks, or signatures standing as proof of the past.

A MONUMENT TO VIOLENCE

LICHTENSTEIN/WAJEMAN: This project necessarily involved requesting passersby to sign the monument against fascism, whereas the cuts and lacerations were not planned in advance.

GERZ: Normally, a signature marks the completion of a work, or a means of identifying it. Here, however, signatures are the essence of the work itself. We had envisaged certain types of reactions, like indifference, for example. Without signatures, the column would have been a simple sculpture, supplemented by instructions for how it should be used. Void of signatures, it would have stood the test of time. It wouldn't have changed form, nor would it have disappeared little by little. We were surprised by the violence of the public. All the signatures were immediately scratched over, blotted out by insults. Some people fired shots at the monument, others used knives, even saws, to cut into it. Before constructing the column, we had friends sign a sheet of lead, in order to see the effect it might produce. When I look at that little piece of lead today, I realize how naive we were. Everyone had signed in a perfectly neat manner, like schoolchildren. We had understood everything and had really understood nothing.

LICHTENSTEIN/WAJEMAN: Violence forms an integral part of the monument.

GERZ: Both Esther and I learned a lot of things from the work in Harburg. This column creates a place of violence and vulgarity, an absence of any degree of aura. It is, however, a place where traces survive. On looking at a slide of this work, I find it beautiful. When I see it as a photographic reproduction, this same violence seems sublime. However, standing before the monument itself, I am prone to see the madness of it and be flooded with sensations of madness, which simply make my stomach turn. I myself would not like to be standing where this monument stands.

LICHTENSTEIN/WAJEMAN: What was it you misjudged?

GERZ: I had not really seen the difference between a reproduction

and the original, even though I hadn't done anything else other than work on this aspect. The difference between the reproduction and the original is similar to that between the beauty of a palimpsest and the fact that erasures, or in our case, scratches, are deep marks that testify to an almost absolute desire to blot out the signatures. In lead, the only way to erase traces is by adding more traces, even if one takes the extreme measure of firing shots at it. It is not really possible to erase something without creating something else. It is impossible, therefore, to erase anonymously. Erasing in lead is not a digital operation of the computer kind, and this can only be properly appreciated if one is up close, standing face to face with the lead and the marks that it bears.

LICHTENSTEIN/WAJEMAN: This unexpected violence sets the pace of the "monumental" process of disappearing as it sinks into the earth. Violence intensifies the movement conducting the column toward its ultimate invisibility.

GERZ: There will be nothing left one day, and this needs to be discussed openly. This necessity to talk is the source of everything. We exist in time, so the trick generally consists in plucking the work of art from the ravages of time and lending it the durability that we mortals lack. I, however would like to subject my work to the conditions of time and confront myself with the lack, the absence of the work. In other words, I would like to take on the role of the work of art for myself and be the element of durability. My aim has been to reverse the relationship between spectators and objects, cult objects, or ones that arouse either fascination or rejection.

LICHTENSTEIN/WAJEMAN: You state that the artist should be his own victim.

GERZ: It is impossible for the color black to be present for me, in my work, while the color white is confined to a sphere apart; for if something exists elsewhere, it is also, as long as I am conscious of its existence, also present for me. Durer said that it is impossible to paint a tree if one is not already a tree.

LICHTENSTEIN/WAJEMAN: The work of art thus functions as memory.

GERZ: Faced with Germany's past, a number of people my age, even those too young to remember events, or born after the war, have always been aware of not knowing exactly how to behave. They exercise a sort of sublime repression of the past. Hence my idea of repressing the work of art. Since Freud's teachings, it is well known that things we have repressed continue to haunt us. My intention is to turn this relation to the past into a public event.

LICHTENSTEIN/WAJEMAN: The German word used in the title for both the Harburg and Saarbrucken monuments is *Mahnmal*. This translates as "monument." There is, however, another word, *Denkmal*.

GERZ: *Denkmal* means monument in the sense of a place for thought, a "think-monument." *Mahnmal* is closer in meaning to an appeal. This word has been in use particularly since the Second World War. In general, *Denkmal* fills the past with a positive sense, *Mahnmal* with a negative sense. The first tends toward commemoration of the "beautiful." The second has a disturbing quality, one that by no means excludes ugliness. Negatively charged past, which has given rise to the word *Mahnmal,* is a powerful tendency today. The continents of America and Australia are in the process of discovering this. Negative past, I believe, will become an increasingly important factor in avant-garde work within, and beyond, the sphere of art. One might well describe "gender politics," or multiculturalism, as an excess of the Puritanism that is characteristic of the United States, but lying hidden underneath all these factors is the overwhelming presence of a past that has been brought into question.

LICHTENSTEIN/WAJEMAN: You are implying that a negative past is a prerequisite for an artistic avant-garde?

GERZ: To a certain extent, yes. Hence the question arises as to whether it is possible to create similar works in France, where "good" past exists in plenty or, at least, where one finds an obsession with good conscience.

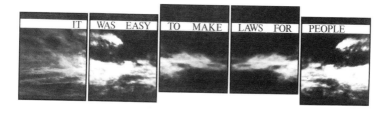

IT WAS EASY TO MAKE LAWS FOR PEOPLE

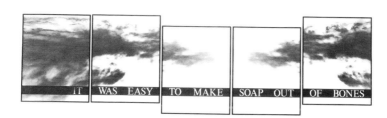

IT WAS EASY TO MAKE SOAP OUT OF BONES

LICHTENSTEIN/WAJEMAN: You moved to France from abroad, and now you live here. How do you feel in this country?

GERZ: I have been here for twenty-seven years now and feel quite at home. A biography is not something that has to be rewritten every time one moves his home.

HISTORY OF THE MONUMENT

LICHTENSTEIN/WAJEMAN: How did the project for the Invisible Monument come into being?

GERZ: After having been invited to teach at the new fine-arts school in Saarbrucken starting in April 1990, I suggested to my students that they should work on the theme of absence. The power of absence, which some people still encounter as a religious, literary, or artistic experience, was in my case a concrete biographical fact, which might be translated as a case of being "too late." This may seem absurd, but I don't think I am the only German of my generation to be concerned by such a feeling. In the castle of Saarbrucken, there is a former Gestapo prison cell, which has been transformed into a museum. The walls of this cell are covered with inscriptions. This is what incited me to begin on another piece that could, like the Harburg monument, last for years. In addition to this, we chose a site for this piece that today, as in earlier times, is a center of government. The regional parliament is located in Saarbrucken, which used to be home to the French high commission, before that to the Gauleiter, the Gestapo, and much earlier than that, to the federal aristocracy. In fact, when I chose this site, we were not aware of all these things or that this site was precisely the "telos" according to which the town had been built. We had chanced upon an appropriate site without knowing it. This is something that has already happened to me in other places, where I have made a somewhat arbitrary choice that has turned out to be the right one.

LICHTENSTEIN/WAJEMAN: Had the idea to use paving stones already occurred to you at the time?

GERZ: Yes, the decision to use paving stones was taken before choosing the site. The alley is made up of 8,000 paving stones. The site provided us with certain problems. The castle houses the seat of parliament and the political parties of an entire local and regional administration. We naturally had to take care not to be caught, therefore. What we were doing was actually completely illegal, especially as the ground is state property. The students were therefore obliged to remove the stones at night and replace them with fake stones.

LICHTENSTEIN/WAJEMAN: In the beginning, therefore, you didn't have a specific site in mind, but simply the idea of paving stones and of cemeteries.

GERZ: The idea to begin working on this piece independently and in secret, without either financial support or legal permission, was one of our first intentions. Another involved engraving onto the underside of the stones the names of Jewish cemeteries that existed at the beginning of the Third Reich — one stone for each cemetery — and replacing the stones in the alley. We spoke to Jewish communities to tell them what we were intending on doing and what we expected from them, and waited to see how they reacted. Naturally, we began in the Saarland, where they gave us the names of twenty-four cemeteries. Afterward, we did the same thing in Rhineland-Palatinate, which covers a wider area of land and which contains more cemeteries. Today, there remain about 30,000 Jews in Germany, the equivalent of the population of a small town. Our findings produced a list of 2,160 cemeteries, which even the Jewish communities did not suspect was so extensive.

LICHTENSTEIN/WAJEMAN: The first effect of this work was to underscore political and administrative shortcomings by producing a list that could have been drawn up a long time ago.

GERZ: Documents already existed, in the Jewish archives in Heidelberg, for example. The Central Council in Bonn has also published a list of 1,948 cemeteries. Our research was a little different, however, because we spoke to each community individually. Most of the

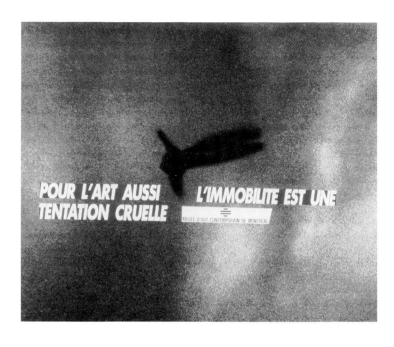

POUR L'ART AUSSI L'IMMOBILITE EST UNE
TENTATION CRUELLE

MUSÉE D'ART CONTEMPORAIN DE MONTRÉAL

YOUR ART IS

MY ART IS A WOMAN DRESSED IN A PRICE TAG AND DOES NOT SEE YOU. MY ART IS A CHILD WITH A THAI STREET RECORD. MY ART IS A COMMON THING FOR FEW PEOPLE. YES WE DO STUNTS. YES WE TAKE ORDERS FROM SOME HIDDEN LORD. MY ART IS A FAST GROWING BOOKY. MY ART IS THE QUEEN OF THE QUOTES. IT IS A HOLY LAND FOR FORTUNE-TELLERS. AND FOR THE DIGITAL CHESS MATE.

students had never spoken to a Jew before. We found that we had access to more information.

LICHTENSTEIN/WAJEMAN: How many stones were used to make the monument?

GERZ: The figure stands at 2,160, that is, *2,160 Stones,* which is also the title of the piece, the subtitle being *Monument Against Racism.* This figure varies. It stood at 312 in the winter of 1990, and at 1,958 a year ago. It could increase even more. Even after the inauguration, the monument will still not be finished.

LICHTENSTEIN/WAJEMAN: What was the reaction of the Jewish communities when they were asked to give the names of cemeteries and the authorization to engrave them on the stones and then to turn the engraved writing face down toward the ground?

GERZ: The people we talked to were often very old and not used to dealing with contemporary art. I told myself that it was a make or break situation. It would have taken only one of the communities in Germany to refuse to give us information for the whole project to fall through. Imagine someone who is eighty-five years old, responsible for a Jewish community numbering just a few people, yet who manages ninety cemeteries and tells you that on no account will he tolerate anyone meddling in his cemeteries! This is what happened with Dr. Kahn in Koblenz. We couldn't do anything about it. He asked me "Why are you putting the stones in the ground so that no one can see them?" My reply was, "Why do you have to be the only one to be afraid and mistrust us?" We obtained the list in the end. At the beginning, the most difficult obstacle was the telephone. We had the impression that we were door-to-door salesmen.

MEMORY IN US

LICHTENSTEIN/WAJEMAN: All of these proceedings require some sort of logistics.

GERZ: We had no funding. This problem didn't arise from the start,

however. Being a professor, I had a telephone, a typewriter, a Mac computer, and a studio. The initial problem consisted in establishing whether art students know how to type a letter. We were confronted with questions that had nothing to do with art. I am, in fact, frequently faced with these sorts of questions. We had no need for the studio. After a month, the school inquired what it was we were constructing, and they were surprised when they discovered we were using the fax and telephone instead of wood or photographs.

LICHTENSTEIN/WAJEMAN: Wasn't the school informed about what you were doing?

GERZ: No. The first people to be informed were the students themselves, of course, followed by two friends of mine in Saarbrucken and the Jewish communities. This lasted about a year, by which time about fifty stones had been laid, without the authorities knowing about it and without a budget to fall back on (it would have been impossible to seek sponsorship without giving reasons).

LICHTENSTEIN/WAJEMAN: Was the title the same one you chose at the start?

GERZ: The first title of the work was *Monument Against Fascism.* Soon afterwards I decided to call it *Monument Against Racism.* With the latter title, the Holocaust becomes a metaphor referring to all racism in general. The idea of fascism, on the other hand, seemed to be almost a convenience. Politicians always have a speech hidden up their sleeves on this subject, just in case. The word "racism" is less well known in Germany, and what's more, it doesn't provoke automatic responses, not among Jewish communities either. This was especially true in Germany in 1990 before the unification.

LICHTENSTEIN/WAJEMAN: Was illegality a prerequisite for the project? If the *Monument Against Racism* had been commissioned officially, would you have refused to launch the project?

GERZ: I don't know. If it really is necessary to *be* a tree in order to draw a tree, it seemed to me fitting not to ask for permission in

75

advance. Racism has been and still is often legally permitted. Or, at least, racism aspires to legality. I could not accept, therefore, that this selfsame legality could serve to commission this work.

LICHTENSTEIN/WAJEMAN: Nevertheless, this monument is now entirely official. It was even inaugurated in the presence of the president of the Jewish community in Germany and several members of parliament. The castle square will also be renamed as "Square of the Invisible Monument."

GERZ: I was obliged to put an end to the illegality in order to enable the work to be carried on. The number of cemeteries was beginning to get out of hand. I couldn't see a way of coming to grips with the situation as more and more information poured in, providing us with ever more things to do. When we used to work in secret, we could lay between twelve and sixteen stones in one night, no more. The castle is protected by a major police station, and of course the students were forced to spend many sleepless nights. On top of this, the false stones were less stable than the original ones and were liable to cause accidents. People in the castle had started talking of "dangerous stones."

LICHTENSTEIN/WAJEMAN: When you spoke before parliament, had part of the engraved stones already been replaced?

GERZ: The first person outside our group whom I spoke to about the project was Oskar Lafontaine, chief minister of the federal state of the Saarland. He helped us out financially, but also said that only the parliament could legalize the project. Rumors had started circulating in the school and around town, and some articles had appeared in the local press. When I spoke before the federal parliament at the end of August 1991, just before the vote was to take place, the representatives were faced with an alternative. They had to choose between either halting, worse still, "vandalizing" a monument that already existed, and which constituted the only one ever constructed with the aid of Jewish communities, or they had to break with their own notion of legality. One of them said, "I am a representative and I am not in a position to support something that

is illegal." Things weren't easy within our own group either. With the number of cemeteries increasing every day, it seemed impossible to finish the work we had started, particularly within the relatively sheltered scope of an art school. I had the vague feeling that the whole thing might fall through. During the session in parliament, television journalists were present, and no one wanted to vote against the motion before the cameras. The conservatives left the room on several occasions. Finally, after almost three hours of debate, they voted against the motion. The project was approved by a small majority.

LICHTENSTEIN/WAJEMAN: Were there any violent reactions or threats?

GERZ: There were some hostile, even violent articles in the local press. Otherwise, in the rest of the country, there were a lot of encouraging articles published on the matter. We did not receive any threats in Saarbrucken, although I thought it better to be cautious when news broke at the end of 1992 about hostels and camps for immigrants being set on fire in the Saarland and elsewhere. A conservative representative told me, "You're inhuman; I shall have to walk over that thing every day!" This is a somewhat ambiguous thing to say, because there is a proverbial expression in German, *mit den Fussen treten,* walk upon, which means to neglect, to show one's contempt for something. Things that are memorable are never situated down low. Our culture is averse to horizontality. Others said that the castle square is not only the most important place in the town but also the place where festivities take place, where people drink beer and piss on the ground! I replied that our feet touch the ground, and there's no harm in that.

LICHTENSTEIN/WAJEMAN: The engraved paving stones are scattered among hundreds of others and cannot be told apart. There is no way of knowing whether one is stepping on original or engraved stones. Isn't this a form of cruelty?

GERZ: Memory is in us, part of our consciousness. What is invisible is invisible. The monument cannot possibly be private property. It's

like the Milky Way. The list of cemeteries will be published eventually. This has been promised to the Jewish communities who gave us their lists.

LICHTENSTEIN/WAJEMAN: It is important to produce the list. Serge Klarsfeld also does this. When we say "six million," it is often forgotten that this means 6,000,000 times "1"— 1, plus 1 ...

GERZ: At the end of the day, all we are left with are lists, columns of data. This amounts to a form of reductionism. There is always one more list to add to the total. Whether it involves signatures or even, as in the project *Dachau* in 1972, inscriptions of the words "Exit," "Entrance," "Woman," "Man," counting is always a central factor. Counting places, time, and people. There is going to be an exhibition in Saarbrucken as well, an exhibition of labels, where the works of art seem to be missing. Each label will bear the name of the cemetery and be situated at fifteen centimeters from the next one along a wall stretching for 320 meters. This enables the immaterial, the number, to be rendered material.

LICHTENSTEIN/WAJEMAN: You rework the past by making a new count of the facts it hides. Is there not a risk that things counted, accounted for, could happen again?

GERZ: That is exactly what I mean when I say that none of that points the way to innocence. It is worth reminding ourselves of Wittgenstein's observation that things we are able to describe can also occur for real.

LICHTENSTEIN/WAJEMAN: One of the strong points of this work, the soundness of its intention, lies in the fact that it does not seek out any guilty partner or moral scapegoat.

GERZ: It is based on the Jewish cemeteries as a metaphor of the most ordinary of things, the most "normal" dead. We confined ourselves to Jewish cemeteries because the Sinti and Roma [gypsies], homosexuals, or mentally sick people for example, who were all persecuted at the same time for racial reasons, in the name of

cultural norms, that is, had no cemeteries of their own. A ceme-
tery signifies a place where someone belongs. Travelers are never
seen carrying their cemeteries, which also goes for artistic cre-
ation. The 2,160 cemeteries remind us of the missing people,
whether they are actually buried there or not.

LICHTENSTEIN/WAJEMAN: The gesture of burying memory has the
effect of raising memory.

GERZ: *Pflaster,* the German word for paving stone, can also refer to
a Band-Aid. Anything that implies immobility, status quo, or even
guiltmongering is dangerous, because it accentuates our inability to
live with our culture.

LICHTENSTEIN/WAJEMAN: This work reveals things that cannot be
expressed or represented. It turns an act into art, a "monstration,"
like demonstration, from the Latin *monstrare,* to show, point out,
or even prove. Monstration always conveys the idea of pointing
one's finger at and singling out a monster, the unnameable.

GERZ: I do not believe anyone can "live" with this past without
more or less repressing it. The repressed past therefore corre-
sponds to the repressed monument. But it is impossible to repress
an absence. This is what the representative meant by the "inhu-
man" aspect of this work. It is essential that there exist a link
between art and its model, and in this case the model is not a
human being but an entire culture. In a way, this monument repre-
sents the photograph of a culture. I don't know if it is even possible
to be a realist, but I would like to create realist art while taking full
account of my subject matter. In order to paint a tree, one must be
a tree. In order to paint this culture, one must be sick, or guilty, or
both. Nevertheless, the denouncing, or moral finger-pointing of the
1980s, remains ineffectual when exercised in the medium of art. I
couldn't continue to work within this context.

LICHTENSTEIN/WAJEMAN: A "realist" approach such as this is a
sort of culmination of mimesis — a representation that is perfectly
appropriate to its contents. This is not really an avant-garde idea. It

could be said to be the most traditional notion in art, or at least the one with the longest tradition.

GERZ: The most favorable thing that could be said about what we are doing is that it tries to serve rather than dominate its subject matter. This attitude was prevalent prior to it being invoked and carried away by the subject matter at hand, or even before it came into being, developing coherent thoughts in its wake. Being faced with this project alone is rather like making up a twosome with the work itself. And all along, the feeling of working from life never left us.

LICHTENSTEIN/WAJEMAN: Working on something entirely appropriate to the original.

GERZ: Where the resemblance must be found beyond the image.

LICHTENSTEIN/WAJEMAN: Such a resemblance implies disappearance, invisibility.

MONSTRATION AND MIMESIS

GERZ: In this nonretinal existence, this laterality, or nonsite, there is a considerable element of pleasure, corresponding to what in English is referred to as "relief." In Harburg, to start with, we were goaded on by "professional" pleasure. The initial idea was clear, lighthearted, but not sad, aiming to change the notion of what is called a monument. We tried to anticipate the number of signatures and imagine the sum total. I conceived of a figure like 70,000 signatures, a number that would have filled a large football stadium. Esther and I ended up getting carried away by the idea of everyday gestures incited by the column, the density of traces, both on the visible portion and the invisible portion sunk in the earth. Afterward, of course, this idea was distorted, and justifiably so. Reality is there in order to distort the concept. I wasn't hurt. Worse still, I was made to see what someone who is "in the know" can let himself in for.

LICHTENSTEIN/WAJEMAN: Although the concept itself contained a distortion.

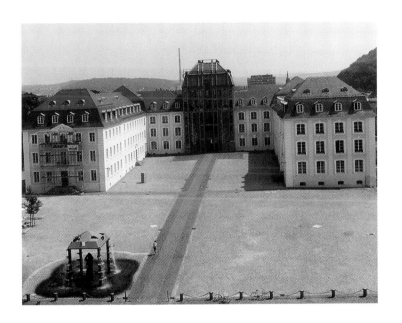

GERZ: In normal circumstances, that's true, but it seems less obvious to me now. Although the concept may not have changed, it's the Harburg monument that has completely evolved in my opinion. I was appalled as I stood before this object, witnessing its changes from one year to the next as it sank into the earth toward its inevitable goal, when, at the end of this year, it is expected to disappear completely.

LICHTENSTEIN/WAJEMAN: This is what distinguishes it as a work of art, because the work itself distorts the concept.

GERZ: The people passing by have brought about this distortion, by literally defacing the work, so it will not be easy for me to thank them.

LICHTENSTEIN/WAJEMAN: In Saarbrucken, on the other hand, you have taken precautions to prevent the work from being defaced.

GERZ: That is the difficulty arising in Saarbrucken — one cannot do anything. It is impossible even to see anything. There's nothing to be gotten out of it. One cannot even determine whether there is logic to the experience evoked by the work. The work doesn't impose itself between its meaning and the viewer.

LICHTENSTEIN/WAJEMAN: It is an object of conversation. It exists precisely because we talk about it.

GERZ: It exists because we are *here*. Memory cannot exist independently of our experience. The work itself accounts for this. Whenever memory weighs down on us too heavily, the work should be cruel. It should, in other words, not stand in as a substitute for us. The feeling of being powerless in the face of memory, of having been born too late to be equal to its challenge, or of being "behind" in general, brings about the impression that one is in a continual state of rebellion. For only life, the "here and now," can be truly experienced, pursued, or changed in relation to memory.

LICHTENSTEIN/WAJEMAN: Couldn't painting serve to cushion the shock?

GERZ: I do not consider painting in a negative light but in an ethnological context. I cannot imagine art working independently of technology. The problems I am faced with do not arise from artistic ethics. True thinking on art is not thinking on art; it's as simple as that. I don't think that the development of tools and techniques goes against the intention of art. All technological and political developments in our society merely constitute a setting up of aesthetic foundations.

LICHTENSTEIN/WAJEMAN: The idea of cemeteries, therefore, concerns not only politics but also aesthetics. It is related to the idea of the death of art.

GERZ: Cemeteries will remain cemeteries. Any old radiator can be called a work of art, any urinal a fountain — but nobody can turn a cemetery into a ready-made.

Jacqueline Lichtenstein is as philosopher who directs the review *Traverses*. Gerard Wajeman is an author and psychoanalyst.

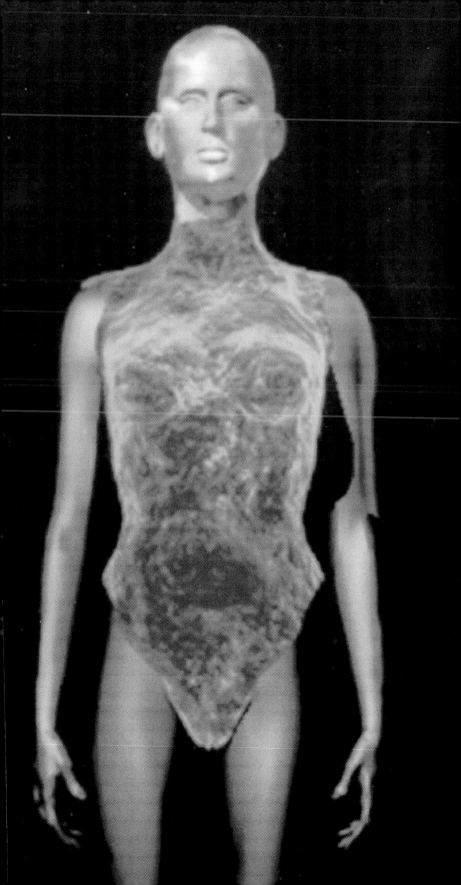

UNDER RE-CONSTRUCTION:

Architectures of Bodies© INCorporated

Victoria Vesna
http://www.arts.ucsb.edu/bodiesinc

Welcome to Bodies© INCorporated. The building elements at your disposal are ASCII text, simple geometric forms, TEXTures, and low-resolution sound. Bodies built become your personal property, operating in and circulating through public space, free to be downloaded into your private hard drive/communication system at any time. The MOO/WOO functions as an institution through which your body gets shaped in the process of identity construction that occurs in, and mutually implicates, both the symbolic and material realms.

BODY CONSTRUCTION ORDER FORM

<Member friendly female voice...>
"Please complete the form below and answer the questions carefully. It should
take only a few minutes of your time."

STEP 1: Personal Information; STEP 2: Body Name; STEP 3: Gender; STEP 4: Sexual Preference; STEP 5: Textures (Member may choose from one of 12 options — Lava, Chocolate, Pumice, Concrete, Water, Sky, Wood, Blue Plastic, Black Rubber, Clay, Glass, and Bronze — for each of the following: head, torso, and right and left arm and leg); STEP 6: Resolution (Hi, Medium, or Lo); STEP 7: Age; STEP 8a: Body Part Selection — External; STEP 8b: Body Part Selection — Internal; STEP 9: Psychic relationship to body; STEP 10: Special Handling Instructions and/or Body Descriptions.

ORDER BODY — Please go over the selections. If Member likes what's been chosen, "SUBMIT" below. If not, then

"CLEAR" to dis-order.

SUBMIT CLEAR

\<new Member SUBMITs\>

Bodies© INCorporated: Member Authorization Agreement
(redistribution encouraged)

By "ACCEPTing," new Member is consenting to be bound by
the following agreement. If Member does not agree to all of the
terms contained herein, then "DO NOT ACCEPT" and the
installation process will abort.

ACCEPT DO NOT ACCEPT

\<Member ACCEPTs\>

DISCLAIMER OF WARRANTY
Free of charge Body is provided on an "AS IS" basis, without
warranty of any kind. The entire risk as to the quality and per-
formance of the Body is borne by said Member. Should the
Body prove defective, Member, and not Bodies© INCorporat-
ed, assumes the entire cost, economic and/or otherwise, of any
service and repair. This disclaimer of warranty constitutes an
essential and unnegotiable part of the agreement.

ACCEPT DO NOT ACCEPT

\<Member ACCEPTs\>

LIMITED WARRANTY
Bodies© INCorporated warrants that for a period of forty (40)
days from the date of acquisition, if operated as directed, the
Body will achieve the functionality described in the documenta-
tion. Bodies© INCorporated does not warrant, however, that
your use of the Body will be uninterrupted, or that the opera-
tion of the Body will be virus-free or secure. In addition, the

88

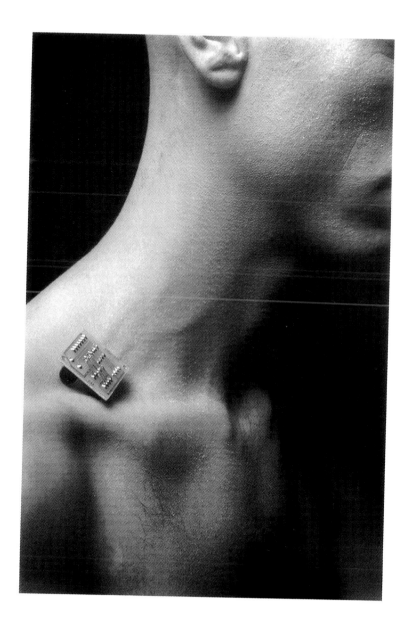

security mechanisms implemented by Bodies© INCorporated have inherent limitations, and it is Member's responsibility to determine that the Body sufficiently meets your requirements.

ACCEPT DO NOT ACCEPT

<Member ACCEPTs>

CONDITIONS OF BODY OWNERSHIP
Member may:

* use the Body on a single computer;
* use the Body on a network, provided that each person access-ing the Body through the network has a copy licensed to that Owner and ONLY that owner;
* use the Body on a second computer so long as only ONE copy is used at a time;
* copy the Body for archival purposes, provided copy contains all the original Owner's proprietary notices;
* permit other individuals to use the Body;
* permit concurrent use of the Body;
* modify, translate, reverse engineer, decompile, disassemble (except to the extent prohibited by law), or create derivative works based on the Body;
* rent, lease, grant a security interest in, or otherwise transfer rights to the Body;
* remove any proprietary notices or labels on the Body.

TITLE
Title, ownership rights, and intellectual property rights pertain-ing to the Body shall become the Member's, and are frequently protected by copyright laws and treaties.

ACCEPT DO NOT ACCEPT

<Member ACCEPTs>

The aesthetic code is strictly enforced at Bodies© INCorporated,

although the Board will take into consideration proposals for stylistic divergence at all times. By joining the Bodies© INCorporated community you have agreed to abide by a principle of radical dissent. This means that you retain the right to dissent, and to remain dissenting, in any activities in which you must choose to participate.

> D&G declare: People ask, So what is this [Body without Organs]?—But you're already on it, scurrying like a vermin, groping like a blind person, or running like a lunatic: desert traveler and nomad of the steppes. On it we sleep, live our waking lives, fight — fight and are fought — seek our place, experience untold happiness and fabulous defeats; on it we penetrate and are penetrated; on it we love.[1]

THERE'S NO PLACE LIKE HOME IS WHERE THE HEART IS

Moving forward through space, on a line of thought formed directly ahead of you, you register, peripherally, many other similarly moving objects. Along the path, you pay close attention to signs that act as reminders of Bodies© INCorporated's stringent rules and regulations. This is your space (and time), some of the few moments when you can be alone with your Body. Below you is a large Motherboard; feeling a strange nostalgia, you zoom in and enter Home.

Home is a gated community plugged into the surrounding chaos via various surveillance cameras and teams of journalists, who venture out to record the status of a separate existence. This daily news is important to the Bodies© INCorporated community, as it reinforces the significance of the stringent rules and regulations that Members have to abide by in order to enjoy a sense of peace and security. Home© INCorporated in 1995, possesses an architecture that hovers somewhere between a circuit board and Disneyland. The Board of Directors has devised a list of rules and regulations, which must be carefully followed. Realize that your total autonomy is itself anything but an exclusive fiction.

"Decency" is defined in strict codes in the virtuality of the material realm; surveillance is firmly established, and privacy demolished.

However, you do have the option of ESCape, or the ability to create your own personal space. As you read the prospectus of Home, a silvery shadow is thrown over your immediate surroundings. David Bohm speaks with a gentle tonality:

> Sometimes permanent (i.e., energy conserving) transitions are called real transitions, to distinguish them from the so-called virtual transitions, which do not conserve energy and which must therefore reverse before they have gone too far. The terminology is unfortunate, because it implies that virtual transitions have no real effects. On the contrary, they are often of the greatest importance, for a great many physical processes are the result of these so-called virtual transitions.[2]

Not sure what to make of this apparitional appearance, you turn your attention back to the legal documentation hanging over you and zoom in on the behavioral provisions. Be aware there are rigid codes of conduct members must follow in order to retain active membership within the Body Owner community. The hierarchy is strictly undefined. The conceptual programmers (also functioning as systems administrators) are the ArchiTexts writ large, who at any moment may penetrate Members' personal space to inspect their actions. They are equivalent to the idea of God/dess. The administrators of the representational realm are the unquestionable Archi-Texts writ small. They are in charge of checking spaces, tracking usage, and bestowing permissions. The Builders are privileged Members who have earned the permission to access the source code required for erecting your world.

RULES AND REGULATIONS FOR HOME

 1) Member's living space must follow the color swatches obtained from the local community administration office. Any colors outside the suggested scheme are absolutely forbidden and may result in fines or even expulsion from Bodies© INCorporated.

 2) Gardenias and other selected flowers should be kept under complete control and allowed to grow no higher than two

@ Home

feet. Use of silicon-preserved plants is encouraged. Bodies©
INCorporated will be glad to provide Member with the
preservation formula.

3) Member's garage cannot be kept open for more than half an
hour; also, Member must remain cognizant of the organiza-
tional structure of the garage's contents.

4) No beat-up cars.

5) Member must avoid too many transportation metaphors. If
Member builds a super-information highway, a randomly
occurring earthquake will most likely destroy it.

6) Member's private construction zone will be purged and Mem-
ber's body sent to Limbo© INCorporated if Member does not
log on and frequently join the critical discourse and energize
the body/space.

7) Once constructed, Member's body cannot ever be deleted;
traces remain even after being disposed of at Necropolis©
INCorporated. Under extraordinary duress Members may
petition to have their traces completely erased.

8) If Members transgress and break the code, Member or Mem-
ber's system may possibly crash or be attacked by a serious
virus. Viral attacks are carefully devised to completely paralyze
all Member's activities while invading Member's mind with
paranoid thoughts (please note liability clause).

Our aim at Bodies© INCorporated is to publicly provide a private
space where the disparate experiences of individual social identities
are similarly portrayed. Culture gets processed and oriented
through Member's body, acting as Cuisinart. In addition, Bodies©
INCorporated proudly boasts the largest archive of dead philoso-
phers — sliced, diced, and intertextually blended — whose ran-
domly occurring thoughts fill the space, serving to keep the level of
discourse constantly circulating on a higher plane. Living cultural
critics, artists, and others are periodically invited in for live chats
with the Body Owner community. Submissions are, of course, wel-
come.

Framed off to the South, you see several large iconographic repre-
sentations of other INCorporated spaces. You pick the one that

reminds you of Home, a rather safe, generic, suburban space; a sprawling housing development resembling a microchip at a distance.

Limbo© INCorporated

Perpetual Existence, a continuation of the entity after the death of said Body Owner. "Transfer of Ownership Interest" — the freedom of each owner to transfer his or her interest in the space without restrictions — is impossible. The following provides a score for each type of entity, based on the preferences listed. This summary may provide some guidance in the selection of an entity form. However, it is inappropriate to select an entity by simply selecting the entity form with the highest number of responses. Each form of entity has advantages and disadvantages that may be more or less important, depending upon the owner's preferences and the circumstances that apply to that specific situation.

A) Enter an X to include an optional section that identifies the owner's preferences regarding important factors that determine the appropriate form of entity.
— Press [Ctrl+D] for more information.
B) Enter an X to include a statement of the owner's expectations regarding the entity's expected level of activity.
— Press [Ctrl+D] for an explanation of how this expectation affects the choice of entity.
C) Enter an X to include a statement by the owner regarding distributions from the entity to the owner.
— Press [Ctrl+D] for an explanation of how this factor affects the choice of entity.
D) Enter an X to include a statement regarding the importance of liability protection for the owner(s).
— Press [Ctrl+D] for an explanation of how this preference affects the choice of entity.
E) Enter an X to include a statement regarding the number of owner(s).
F) Enter an X if it is expected that there will be only one owner.
G) Enter an X if it is expected that there will be at least two bod-

ies but not more than 35.

H) Enter an X to state the importance of other factors to the owner(s).

— Press [Ctrl+D] for an explanation of how these factors affect the choice of body entity.

I) Enter an X if it is important that the form of body survive the death(s) of the owner(s).

J) Enter an X if it is important to the owners to be able to freely transfer their respective interests in the space to other parties without restrictions.

— Press [Ctrl+D] for more information.

Bodies© INCorporated calculates the number of responses that are favorable to the establishment of a SOLE PROPRI-ETORSHIP, a GENERAL PARTNERSHIP, and a LIMITED PARTNERSHIP. Bodies© INCorporated calculates the number of responses that are favorable to the establishment of an "X" or unknown INCorporation. Finally, Bodies© INCorporated calculates the number of responses that are favorable to the establishment of a LIMITED LIABILITY BODY.

SUBMIT CLEAR

<Member SUBMITs>

You find yourself in a passage with a fluorescent light, flickering above a broken "Enter" sign making a buzzing noise, inviting you in. You are somewhere, neither here nor there, while everything that seems to matter remains at a distance. A Vortex Vector unexpect-edly sucks you into a deep indigo blue space with no sound, text, or conceptual reference points. Just as you start feeling the infinite transitional possibilities dis-place offers, you emerge into Limbo© INCorporated.

"Hypertextualized bodies in limbo — a region where immateri-alized thought-forms are detained until final judgment — abstracted from the temporal flow, discontiguous, disarticulat-ed, inert and constrained. Gestational body-as-prosthesis,

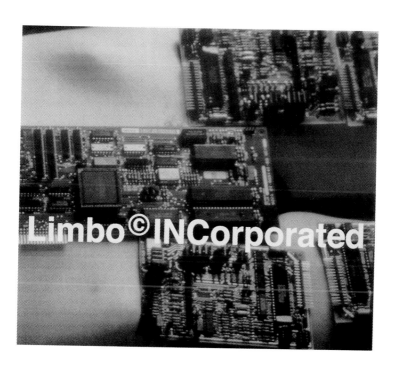
Limbo©INCorporated

enabling psychological acclimation to an aethereal self-as-other."[3]

A legal form hovers above, giving you the option of ESCaping. If you don't successfully exit out of Limbo© INCorporated in 40 days, you will remain ensnared forever, with only your e-mail left as a trace. A sprawling row of gray cubicles extends before you. The fluorescent light is damaged, blinking and making an unsettling sound of permanence and static, as a bubble-jet printer spews out continuous streams of the defunct body orders of those stuck in Limbo© INCorporated. You are returned to screen-based communication, textually prompted, and have lost the power of immersion and interaction. All you can access is an enormous list of body orders with an endless row of e-mail addresses that have become inert and disabled. You become mesmerized at how incredibly boring and nondescript the space you are in is, though you stay for ages, scrolling through the immeasurable forms. After almost nodding out, you decide to try and leave.

You realize the obligation/commitment you have made by submitting to the initial contracts and shudder at the thought of being trapped here forever. Behind an opaque glass ceiling, you notice a female form. You zoom in, focus, and find Ada, musing on the meaning of "Zero." She is transparent, frozen in time, while under chloroform sedation, and the glass surrounding her delicately inscribed:

> "Zero is *something,* though not some *quantity,* which is what you here mean by *thing*. Some writers in the differential calculus use not 0, but 0/0, in an absolute sense, as standing for a quantity…Absolute modes of speaking, which are false, are continually used in abbreviation of circumlocutions."[4]

The exit sign is nowhere to be found; your keyboard is sticky and stiff, preventing you from being able to type the exit command. Just as you start to give up and begin contemplating the meaning of inertia, a fire escape finally appears. You find yourself in a short corridor. To the North is the Conference Center, to the East, the

Library, and to the West, some offices for rent. You see the New Projects board here and decide to apply for a permit to construct a private architecture. Of course, this initiates another long and formalized list of rules and regulations at the site of the ArchiTextural Authority.
<Member enters>

BUILDING CODE CENTRAL

It should be noted that the strategy of screening heterogeneous TEXTures with homogeneous fronts is to view the body from the inside. The mission of the exterior envelope is to make a barrier against the outside. Although spaces may be constructed out of heterogeneous building codes, the resulting protective structures must behave as though they are homogenous and continuous.

ACCEPT DO NOT ACCEPT

<Member ACCEPTs>

Reading the enormous list of provisions, you highlight the six elements that will be of main concern: Noise, Fire and Water, Lights, Camera, and Action.

NOISE
The building code enforces protection from noise at the boundary of each separate body. Noise is ubiquitous. Ideally, noise protection can be understood as a seamless layer, bounding and protecting Member's dwelling container. Densification of concrete TEXTures are essential in order to dampen sounds and prevent them from entering the Member's private space.

FIRE AND WATER
The building code distinguishes between groundwater and

water from the sky. A Fire-Wall has been assigned a number of nanoseconds (ranging from 1 to 70) designating the length of time it may be expected to survive in the event of code breaching. The struggle (of fire protection within the confines of the code) is between the individuality of these disparate components and the homogeneity of surface.

LIGHTS

Provisions of light infringe upon the privacy created by opaque barriers; each addition causes an erasure of solidity. Just as clothing only partially covers the body, the light's spatial dimension only partially drapes its occupants. The provision for light treats each body as a complete entity, helping to define the boundary between the outside and the inside of the space itself, a small-scale version of the previous conception of the whole-as-medium.

CAMERA

Laws of camera movements are governed by rigid rules, though Members have multiple lenses available for their viewing pleasure. Be aware, fish-eye lenses require two weeks' notice. Pinhole lens codes are only obtainable by special request to the archiTexts and require outstanding proposals for granting consideration. NOTE: Frames of reference generated by Member's POV are completely contextual and non-negotiable.

ACTION

The Body is fault-intolerant and is not designed or intended for use as online control equipment in hazardous environments that require fail-safe performance, such as in the operation of nuclear facilities, aircraft navigation or communication systems, traffic control, life support machines, or weapons systems in which the failure of the Body might lead directly to death, personal injury, or severe physical, mental, and/or environmental damage. Bodies© INCorporated specifically disclaims any express or implied warranty of fitness for such "High Risk Activities."

ACCEPT DO NOT ACCEPT

<Member ACCEPTs>

"Sorry, your current USERID and/or Password was not found in the Member Directory. Member can register for a Guest Password, activated for 24 hours, here. Please enter your e-mail address and logon as Guest."

E-MAIL CLEAR

<Member selects E-MAIL>

"Sorry, your current USERID and/or Password was not found in the Member Directory. Member can register for a Guest Password, activated for 24 hours, here. Please enter your e-mail address and logon as Guest."

E-MAIL CLEAR

<Member selects E-MAIL>

"Authorization failed. Retry?"

OK CLEAR

<Member CLEARs>

"Server Error. This server has encountered an internal error that prevents it from fulfilling your request. The most likely cause is a misconfiguration. Please ask the ArchiTexts to look for messages in the server's error log."

OK

<Member SUBMITs>
Well, That Didn't Work!
Are you sure you're a Bodies© INCorporated member?
Try retyping your member name and password.

The unauthenticated version of that page may be found here.
If you're not a member yet, you can join Bodies© INCorporated.
Did you forget your password?
Don't stress. We'll give you a new one.
If you've forgotten your member name, we can remind you
through e-mail.
Is your browser compatible with our site?
Bodies© INCorporated supports most browsers, but it never hurts to
use our proprietary browser.
Still feeling lost?
We're here to help!
You can also drop us a line.

Note: Your registered e-mail address is the address you entered when you signed up for your Bodies© INCorporated Membership. Your password change information will be mailed to this address. If you have moved, please write to address@Bodies© INCorporated.org. Include your first and last name, Member-name, and both your old and new addresses in your correspondence.

OK

<Member SUBMITs>

.esrever ni rotceV xetroV

NECROPOLIS© INCorporated

A wind whispers in from the East, blowing across the terrain of Necropolis© INCorporated. A scent of fire and incense wrapped in a darkly shrouded mist rolls in softly with the ash, enveloping your being. You are gently summoned to enter the dark and foreboding, yet oddly inviting Necropolis© INCorporated. You come to the sudden realization that your desire for rational and calculated control has more to do with a drive toward death than with a love of life.

1. Distributions to Body parts…
2. Death of a Body…
3. Personal Property Distribution…
4. Residuary Assets…
5. Right to Direct Death…
6. Revoke or Amend Governing Law of Perpetual Life Clause…
7. Severability…
8. Miscellaneous Provisions…
9. Terminal Identity…
— Press [Ctrl+D] for more information.

A) This required section explains distributions that will be made to the Bodies during their joint lives with the Owners, and includes provisions regarding the possibility of a Body becoming "disabled."
B) This required section provides for the continuation of the Trust upon the death of one of the Bodies.
C) This optional section permits the distribution of specific property to named beneficiaries.
— Press [Ctrl+D] for more information.
D) This required section provides for the distribution of the intellectual assets upon the death of the surviving Body.
— Press [Ctrl+D] for more information.
E) This required section includes standard powers for the Owner.
— Press [Ctrl+D] for more information.
F) This optional section includes optional Owner powers.
— Press [Ctrl+D] for more information.
G) This section describes how the Owner can revoke or amend the Body. After a Body dies, the surviving Owner can continue to receive distributions or revoke the Body.
— Press [Ctrl+D] for more information.
H) This required section provides that the entire document will not be invalid simply because one of its provisions was (or became) invalid under state or federal law. Bodies© INCorporated will provide the appropriate acknowledgment form for the state that is entered here. Bodies© INCorporated selects "Sole Trustee" by transferring your choice from the first sec-

tion. If you wish to name Co-Trustees, you must return to that section. Enter an X if the Sole Trustee is a corporation, rather than an individual.

This Agreement amends and restates any prior Agreement. In consideration of the mutual covenants and promises set forth in this Agreement, the Owner and the Body consent to do as follows:

PURPOSE
The purpose of this Agreement is to establish a Trust to receive and manage the Body during the Owner's life, and to further manage and distribute the assets of the Trust upon the death of the surviving Owner.

FUNDING OF TRUST
Any community property transferred to this Trust shall remain community property until the death of either Grantor. This Trust may also receive property from any person or entity who is acting under the authority granted to that Body or entity by the Owner. It is also expected that this Trust may receive assets pursuant to the terms of either of the Owners' Last Will and Testament. [see Owner's Death Section (1 of 40)]

DEATH OF A BODY
Upon the death of the first of the Bodies (the "Descendent"), this Trust shall continue for the benefit of the surviving Owner, subject to distributions (if any) that may be required (i) by this Agreement, or (ii) to pay the just debts, funeral expenses, and expenses of last illness of the freshly Deceased.

FORTY-DAY SURVIVAL REQUIREMENT
For the purposes of determining the appropriate distributions, no person or organization shall be deemed to have survived the Body, unless such person or entity is also surviving on the fortieth day after the date of that Grantor's death.
<Member friendly female voice...>
"To ensure that you will only LOOK at bodies, tremendous

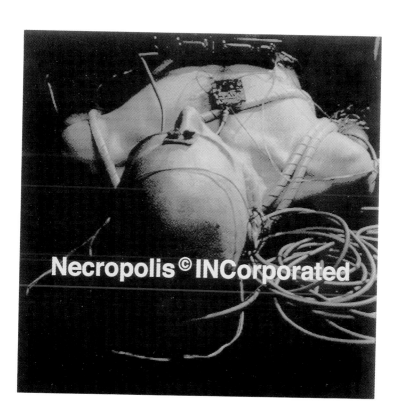

fail-safes have been established to maintain security. Please fill
out the Identity Verification Form."

<Member fills out form>

<Member friendly female voice...>
"Thank you for your compliance."

You gain entry and find yourself floating in space, looking down on
a vast VRML webscape of what appear to be endless rows of cubes
with e-mail addresses. Silicon-preserved plastic flowers fill the
space, as do streams of primitive wire-frame models. The environ-
ment is pleasantly lit and very inviting; you notice a musty incense,
agreeable mixtures of Indian ragas, Tibetan chants, and Renaissance
harpsichords with reverbed reggae rub-a-dub.

<Member friendly female voice...>
"Here to LOOK or to DIE?"

LOOK DIE

<Member LOOKs>

You notice Bataille sitting at a Terminal and zoom into his screen:

"The victim dies and the spectators share in what [the] death
reveals. This is what religious historians call the sacramental
element ... the revelation of continuity through the death of a
discontinuous being to those who watch it as a solemn rite. A
violent death disrupts the creature's discontinuity: what
remains, what the tense onlookers experience in the succeed-
ing silence, is the continuity of all existence with which the vic-
tim is now one."[5]

You continue to move in and find yourself in a vast, open terrain. A
strong transcendental wind blows you around. To the West, you
see a huge logo of Bodies© INCorporated hovering above an enor-
mous building resembling a museum. To the South lies the vast,

sprawling housing development of Limbo© INCorporated. Between the two, at a diagonal, you can make out 1,001 plateaus. What looked like cubes are identical dark gray tombstones with shiny luminescent holographs of e-mail addresses. You check to see if you can find out whether the body buried at the tombstone belonged to an organization, an educational institution, the military complex, or a simple commercial domain.

You decide to communicate with the dead by clicking on the e-mail in order to send a message to the embedded address. Unexpectedly, an O-Bit of the Body encased within flies out for you to read. Unfortunately the address itself is no longer accessible, since the body owner elected to deactivate it. You zoom into what seems an interesting name on another tombstone nearby, "Worm," to try to request a talk session, and receive the following message almost instantaneously:

> "Death as spectacle, spectacular death — now graphically materialized, soon to be de-materialized, thought-forms — where psychological attachment is activated by the prospect of (psychic and terminally) projected loss. The dis-embodied becomes emotionally charged, ready to be horrifically realized, consequentially committed, and ex(or)cised."[6]

On a slowly spinning color-saturated videocube are images of baroque floral arrangements, with ribbons and gold letters. You click one of the sides of the cube and a death advertisement is launched:

> "Over 5,000 methods of death to choose from! NEW and IMPROVED ways to die added daily! These methods are compiled by our DEADicated HOME surveillanceteams, working to keep Bodies© INCorporated at the bleeding edge of techno-logical advancement. See your death broadcast in SHOW-PLACE!!!© INCorporated to the ENTIRE Bodies© INCorporated community, FREE OF CHARGE!"

You get an increasingly uneasy feeling in the pit of your stomach. Suddenly you are notified that your time to LOOK has expired.

The whole screen gets progressively filled with O-Bits, and out of that confusion emerges...

SHOWPLACE!!!© INCorporated

1. Confidential Information...
2. Protection of Information...
3. Return of Information...
4. No Obligation...
5. No Warranty...
6. General Provisions...

A) This required section requests information regarding the parties to the Confidentiality Agreement and the reason(s) why the Agreement is being made.
— Press [Ctrl+D] for more information.

B) This required section explains what the parties mean by the use of the term "Confidential Information."
— Press [Ctrl+D] for more information.

C) This required section explains the Recipient's obligation to protect the information from possible disclosure to third parties.
— Press [Ctrl+D] for more information.

D) This optional paragraph requires the Recipient to return the Confidential Information to the Body Owner at the request of the Body Owner.
— Press [Ctrl+D] for more information.

E) This optional section indicates that the Body Owner is not making any warranties to the Recipient regarding the Confidential Information.
— Press [Ctrl+D] for more information.

F) This optional provision confirms that the Recipient has the right to use the Confidential Information only for the limited purpose(s) stated at the beginning of the Agreement.
— Press [Ctrl+D] for more information.

G) This required section provides general provisions that should be included.

H) This optional section allows for additional provisions of your choosing.

— Press [Ctrl+D] for more information.
l) This required section provides signature lines for the parties.

The Confidentiality Agreement is an agreement under which a party (a Recipient) agrees to maintain confidentiality regarding proprietary information that it receives from another party (a Body Owner). Enter a term that will be used in the Agreement as an abbreviated version of the Body Owner's name. For example, if the party's name is "Jane Doe," enter "Bodies© INCorporated Jane Doe." Enter the name of the person or entity (the "Body Owner") that owns the Confidential Information that is to be disclosed under this Agreement or edit the information as desired. Enter the name of the person or entity (the "Recipient") to whom the Confidential Information will be disclosed.

CONFIDENTIALITY AGREEMENT

This Confidentiality Agreement (this "Agreement") is made effective immediately. In this Agreement, the party who owns the Body will be referred to as "X," and the party to whom the Body will be disclosed will be referred to as "Y." "Z" will protect the confidential material and information that may be disclosed between "X" and "Y." Therefore, the parties agree as follows: Enter the name of the person or entity (the "Body Owner") that owns the Body that is to be disclosed under this Agreement or edit the information as desired. Enter the Body Owner's street address. Enter the Body Owner's city or edit the information as desired. Enter the Body Owner's state/province or edit the information as desired. Enter the Body Owner's zip/postal code or edit the information as desired. Enter the country. Enter a brief description of the Body Owner's business or activities that involve the confidential information. For example, Body Owner is engaged in "the business of manufacturing computer memory." Enter a brief description of the Recipient's business or relationship to the Body Owner. For example, The Recipient is engaged in "marketing computer memory." Enter a brief explanation of why the confidential information will be disclosed to the Recipient.

When done, please submit.
SUBMIT CLEAR

<Member SUBMITs>

CONGRATULATIONS!
You are now free to go anywhere and free to do and/or buy any-
thing. TOTAL democracy reigns supreme, and happy consumers are
handsomely rewarded. You enter Showplace!!!© INCorporated.
Immediately available is a mirror image of your self. The camera
zooms in; you feel an enormously warm and glowing light directly
above you. Your image is projected onto a large billboard that mil-
lions of people are viewing. Appearing larger than life gets you sexu-
ally aroused. You are being watched by countless eyes and through
multiple lenses — all in sharp focus. Thousands upon thousands of
corporate logos, from every imaginable hardware and software
company, fly around you, making a hypnotic hum. You reach out for
the newest, shiniest, most improved item and type in your credit
number.

> Artaud says: "I renounce nothing of that which is the Mind. I
> want only to transport my mind elsewhere with its laws and
> organs. I do not surrender myself to the sexual mechanism of
> the mind, but on the contrary within this mechanism I seek to
> isolate those discoveries which lucid reason does not provide. I
> surrender to the fever of dreams, but only in order to derive
> from them new laws. I seek multiplication, subtlety, the intellec-
> tual eye in delirium, not rash vaticination. There is a knife which
> I do not forget."[7]

You move through the space and notice discussion forums, bodies
to view, a special section of star/featured bodies, and people crowd-
ed about betting on what appears to be text scrolling by, announc-
ing something related to the prospect of death and dying ("dead-
pools"). You enter a discussion forum and witnesses a "live" chat
session (the Topic of the Day) linked to a special issue of *SPEED;*
there are constant interruptions by flying logos with embedded

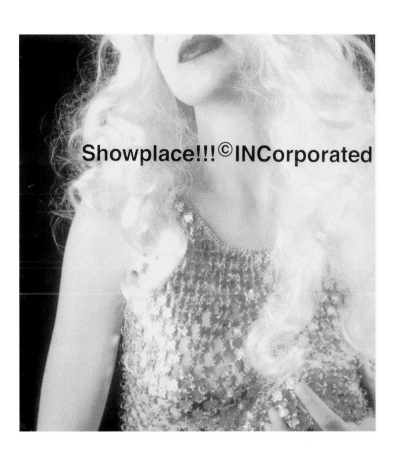
Showplace!!!©INCorporated

commercials.

You go to view the "body of the month" (announced earlier over the public PA), and notice its impressive CV (with an extensive exhibition record), beautiful auratic lighting, tracking cameras, embedded textures updated in real time, streaming sounds, collision detection, java applets, and shockwave animations. You realize that this is no mere appropriation but an incredibly elaborate customization — the code is untouchable, impenetrable, uncrackable. You know that you'd need years of training to achieve this level and wonder if perhaps what you are contemplating is an archiText writ large. You are overwhelmed by feelings of inadequacy and question if you'll ever be able to achieve the level of proficiency needed to achieve such a state. You suffer a bad case of Member envy.

"Thus I shall have to be satisfied," Freud says, "with evident dissatisfaction. If I succeed in deriving the core of his delusional formation with some certainty from familiar human motives."[8]

NECROPOLIS© INCorporated

A wind whispers in from the East, blowing across the terrain of Necropolis© INCorporated. A scent of fire and incense wrapped in a darkly shrouded mist rolls in softly with the ash, enveloping your being. You are gently summoned to enter the dark and foreboding, yet oddly inviting Necropolis© INCorporated. You come to the sudden realization that your desire for rational and calculated control has more to do with a drive toward death than with a love of life.

<Member friendly female voice...>
"Here to LOOK or to DIE?"

LOOK DIE

<Member DIEs>

DONOR DATA

1. Information…
2. Donation…
3. Designation of Organs…
4. Designation of Use Special Limitations…
5. Designation of Donee…
6. Revocation or Amendment…
7. Severability Signature…

A) This required section provides information regarding an individual's consent to donate or the refusal to donate organs or tissues. There are no entry fields in this section.
— Press [Ctrl+D] for more information.
B) This required section includes the Donor's name and address. The Donor is the individual who is donating organs, tissues, or body parts to be removed after the Donor's death.
— Press [Ctrl+D] for more information.
C) This required section allows the Donor to indicate specific limitations or wishes concerning the donation of the Donor's organs, tissues, or body parts.
— Press [Ctrl+D] for more information.
D) This optional section allows the Donor to designate an individual or institution to receive the donation (the "Donee").
— Press [Ctrl+D] for more information.
E) This optional section revokes or amends any prior documents and should be completed by any Donor who has previously completed an organ donation form or a "refusal to donate form."
— Press [Ctrl+D] for more information.
F) This required section provides that the inclusion of an invalid request or instruction does not invalidate the other provisions of the document.
— Press [Ctrl+D] for more information.

Enter the Member's state of residence. Enter an X if the Member wishes to donate any needed organs, tissues, or body parts. The Member must also initial this choice on the printed form. Enter an X if the Member wishes to donate any needed organs, tissues, or parts except one or two specific organs. The Member must also ini-

tial this choice on the printed form. Use this space to describe which organs are NOT to be donated. For example, "heart" or "eyes." This option allows the Member to state which specific organs, tissues, or parts to donate. Enter an X if the Member desires to donate the heart at death. Enter an X if the Member desires to donate heart valves at death. Enter an X if the Member desires to donate lungs at death. Enter an X if the Member desires to donate kidneys at death. Enter an X if the Member desires to donate the liver at death. Enter an X if the Member desires to donate the pancreas at death. Enter an X if the Member desires to donate intestines at death. Enter an X if the Member desires to donate bone at death. Enter an X if the Member desires to donate skin at death. Enter an X if the Member desires to donate blood vessels at death. Enter an X if the Member desires to donate eyes at death. Enter an X if the Member desires to donate musculoskeletal structures (for example, tendons or ligaments) at death. Enter an X if the Member desires to donate body fluids at death. Enter an X if the Member desires to donate other tissue or cells at death. Enter an X if the Member desires to donate a pacemaker at death.

<div align="center">SUBMIT CLEAR</div>

<Member SUBMITs>
Surprisingly the death space is flooded with a beautiful soft light and covered with fabulous floral arrangements. The flowers, all preserved with silicon, have tremendous lifespans. You begin scrolling through the endless Methods of Death list…

#2005: asphyxiated with black plastic bag
#2000: guts slit and the half-digested food in your intestines munched on by a sexually dysfunctional lumberjack
#1800: dismembered and a magic stew made out of your heart, genitals, and spine
#1003: skull crushed with a rock
#0102: dismembered and stuffed in pillowcases
#0101: passed away during sleep
#0092: sodomized before and after being decapitated
#0091: handcuffed, anally raped, and beaten to a pulp, while offered peanut butter and jelly sandwiches, being recited

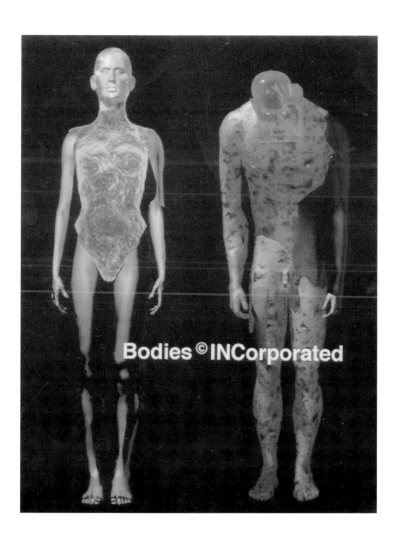

Bodies©INCorporated

verses from the Bible, and getting strangled

#0089: turned into a zombie after receiving a homemade lobotomy and having acid poured into body cavities

#0088: mangled by a man who implanted needles in his genitalia, stuffed his asshole with flaming alcohol balls, ate shit, killed children and made stews with their remains

#0087: rendered unconscious and then strangled and fucked simultaneously

#0086: shot by a man who came in your mouth just before chopping your head off

#0085: your blood drained and blended with body organs and drunk by a man in order to stop his own blood from turning into powder

#0084: brutally raped and strangled and dumped in a neighboring village that bore the same first letter as your e-mail address

#0023: terminally dehydrated from colon cancer

#0009: choked on your own vomit[9]

You take a deep breath and decide to put your body to rest during sleep (death method #0101). Almost instantaneously, just prior to pressing the KILL button, you are presented with an O-Bit page to fill out. The results of your self-inflicted memoriam will be announced to the entire community of Body Owners. Because of the incredibly spectacular public nature of the announcement heralding your Body's passing, you decide to take extra time with wording your obituary. It is with great relief that you press the "KILL" command.

KILL ABORT

<Member KILLs>

A Vortex Vector unexpectedly sucks you into a deep indigo blue space with no sound, text, or conceptual reference points. Just as you start feeling the infinite transitional possibilities dis-place offers, you emerge at the Home of Bodies© INCorporated.
BODY BUILDING

Welcome to Bodies© INCorporated. The building elements at your disposal are ASCII text, simple geometric forms, TEXTures, and low resolution sound. Bodies built become your personal property, operating in and circulating through public space, free to be downloaded into your private hard drive/communication system at any time. The MOO/WOO functions as an institution through which your body gets shaped in the process of identity construction that occurs in, and mutually implicates, both the symbolic and material realms.

BODY CONSTRUCTION ORDER FORM

<Member friendly female voice...>
"Please complete the form below and answer the questions carefully. It should
 take only a few minutes of your time."

1. Gilles Deleuze and Felix Guattari. *A Thousand Plateus: Capitalism and Schizophrenia* (London: Athlone Press, 1988), 150.
2. David Bohm, *Quantum Theory* (New York: Prentice-Hall, 1951), 415.
3. Victoria Vesna and Robert Nideffer "Bodies© INCorporated: Theoretical Appropriation for Somatic Intervention," 1996.
4. Dorothy Stein, *Ada: A Life and a Legacy* (Cambridge: MIT Press, 1985), 72.
5. Georges Bataille, *Erotism: Death & Sensuality.* (San Francisco: City Lights Books, 1986), 82.
6. "Bodies© INCorporated."
7. Antonin Artaud, *Selected Writings* Susan Sontag, ed.; translated from the French by Helen Weaver (New York: Farrar, Straus and Giroux, 1976)
8. Peter Gay, *Freud: A Life for Our Time* (New York: W.W. Norton & Company, 1988), 283.
9. http://www.mayhem.net/crime/archives.html

ALIEN STAFF

Krzysztof Wodiczko

in conversation with *Bruce Robbins*

BRUCE ROBBINS: A passerby in the street sees someone holding a walking stick with a TV monitor on top like a hooded cobra. There is a moving image; there is the sound of a voice, perhaps an accented voice. The person holding the staff seems to want to make eye contact. What goes through the passerby's head? Another crazy foreigner? Someone who needs help walking? Moses in front of Pharoah?

Some of the brilliance of this seems to me the play on what Guy Debord calls "the society of spectacle," on the fact that people will not stop for human beings telling their story but will stop for a televised image of the same human being telling the same story. When the image replaces the person, when there's an obstacle between you and the person, there's a better chance of making contact. Otherwise the operator is likely to be taken as someone asking for spare change. Is this what you had in mind? What sort of public encounter are you striving or hoping to produce?

KRZYSZTOF WODICZKO: It's very hard for me to present a theoretical model for what I hoped would happen, or even what I noticed did happen during these performative presentations. But it was clear that without this object, none of this would happen. Any kind of object held and operated by a stranger can be useful. But if the object performs and is attractive by virtue of being strange, it relates to the tradition of strangers, magicians, performers using instruments that come from somewhere else, to make magic, or just to sell something. In the environment of the contemporary city, too, a new object is always desirable. The first thing people wanted to know about the *Homeless Vehicle* that I designed earlier was whether it was something they could buy. Strange objects that are brought by foreigners are usually available for purchase.

121

ROBBINS: Is there an answer to the question "Can it be bought?"? Do the people who use these instruments have any idea whether they can be bought or not?

WODICZKO: I can respond to this question in terms of its relation to the art market and to museology. But the *Alien Staff* proved to be very effective because it was recognized as something familiar at the same time as something strange. It's like a cliché; a Biblical staff.

It's clear people don't understand at first why it resembles something. Later they draw conclusions. Then there was the Wandering Jew myth. Some would see it as an icon of the Wandering Jew. At first people concentrate on the object, as a cliché. Then they get closer to see what's happening on the little monitor. It's very small. To get close is to cross a certain boundary. There's a face on the screen. A face, *the* face: the face of the Other.

ROBBINS: Does Emmanuel Levinas laugh when he talks about the face of the other?

WODICZKO: The face here is the face of a character and the face of an actor at the same time. The face of a media performer and an actual person. And there is the operator also an actual immigrant who is performing in relation to the prerecorded image. The presence of the actual immigrant takes several forms. One of the forms is to embody disagreement with what was prerecorded. Nothing here is very stable. It's quite open for exploration. When others ask questions about what's in the containers, for example, it brings up things that weren't said in the prerecorded material. But very often the immigrant will also refuse to explain. They'll say, "It's none of your business. It's there because it's important to me." Other things are explained even if nobody wants to hear. Horrifying descriptions of the immigration department and so on. You ask for it, you get it.

Then there is yet another person, a person from the crowd — the beginning is the gathering of a crowd, and things are already leaking out of this two-person encounter with the crowd — which is listening to all of this and is voicing its own opinion: "Well, excuse me, I'm also an immigrant," or "I'm not an immigrant, but...." Levinas' "third" is the person who says, "I am not an immigrant, but...."

This is the person who sees the whole situation from the point of view of a symmetrical democratic project. In France, which lives the classic democratic Enlightenment, the third is the person who says, "But wait, aren't we all members of one large community?"

This triple relation — me, the other, the third — can be reversed. Any one of these can be the one who sees the triple relation. But the object helps in this process. It makes a multiple. This artifice, the *Alien Staff,* doesn't really exist for Levinas.

ROBBINS: Nor the multiplicity, does it? It's a big difference between you and Levinas.

A TALMUD FOR IMMIGRANTS

WODICZKO: Levinas implies the possibility that the other can be found within the other. In his Talmudic readings, there is that multiplicity. He's describing the pact. The oral tradition, as he points out, is not only a commentary on written texts like the Torah; it's equally important to Torah. Some scholars demanded that God should read the Talmud. Levinas' emphasis on Talmud as the most Jewish thing that exists is an emphasis on unending argument, disagreement, discourse. Maybe there's something Talmudic about what happens around the stick. [Laughs] In a minor, microcosmic way. It's a history of the present. People live through being an Arab, or a Jew, or a Polish immigrant in Greenpoint. It opens up for rereading, recollection, remembrance — all those things Walter Benjamin speaks about — without a particular place, without the Temple.

ROBBINS: I'm really fascinated by one aspect of your work that seems to me unique. It seems to be designed so as to require a kind of narrative completion. To stop and provoke conversation about it and between people who are involved in it which is a kind of building block of some new community. It's artistic work that provokes and invites intellectual and communicative activity in a very special way.

WODICZKO: When you say a special way, I can only imagine what you mean. What I've tried to do, that I don't see being done

enough, is perhaps the creation of some object or some intermediate form which inspires, becomes a starting point for the openings and exchange, and sharing. And that is something that continues a tradition of the need of object or instrument, like a storyteller's instrument. A kind of magic staff that will make miracles. As in the Bible. It is clearly stated in the Catholic version of the Bible that the staff is to make miracles. In the Protestant version, it says to make a sign. But in both cases there is a magic to it. Without the stick, people would not believe the person who was using it. But in this case the object can also become a center, a sacred place. Georges Bataille defines the sacred place as the place where passions are unleashed, where something can be shared that has not yet been shared or is not supposed to be shared, like Jean–Luc Nancy. It is the place of a birth of some kind. This object is a performative object. I think we need more objects of this sort to come between an incredible explosion of unprecedented telecommunication technologies and a dangerous return to the tragic precedents of complete communication breakdown.

How would you connect the Media Lab, the most advanced technological media experiments, with the situation of the ex–Yugoslavia? They are almost almost irreconcilable events. In the space between these two points of reference, in normal everyday life, there is a need for people to recognize each other and take responsibility for each other, which is a highly difficult mission. Definitely recognize each other, face to face. How to do this and at the same time to create, to take advantage of the global communication networks? It's a very personal, very fragile thing. And very direct contact, with all the resources, the historical documents or past cases, we can bring to it — how to bring forward the whole heritage of accumulated layers of the past and wrestle with it when we are actually facing each other? I'm told that tragedy will not repeat itself, so there may be no more ex–Yugoslavias. I think there is still a reasonable hope. Can artists be part of this larger range of efforts? We need a more concrete hope, a clearer agenda. Not just an understanding that we will never reach the point but also an understanding that we *must* reach the point. To bring together communication technologies and interaction, direct con-

THE ALIEN STAFF

EYE LEVEL

XENOSCOPE
(exterior surface
made of copper)

HANDLE
(made of brass)

To the
video
player
and
batteries
located
inside
shoulder
bag

XENOLOG
(metal elements added yearly,
records "history" of
alien-operator—xenologist)

3 yrs.
permanent
residence

extending
temp. work
permit
4 times
(4 years)

extending
visitor's
visa 3 times
(3 years)

entry denied
at border

waiting for
entry visa

waiting for
exit visa

exit visa
denied

FOOT
(changeable length to secure
eye level position of xenoscope)

Side-view with
cross-section

Example of Alien Staff
(frontal view)
with 13 carved notches—
symbols of immigrant's
history (xenolog).
Operator (xenologist)
explains the story behind
them on screen.

KRZYSZTOF WODICZKO
PARIS, 1992

tact, aesthetic work needs instruments, equipment, but it also needs to create events, acts, so that in facing those events people will start communicating directly. In a way, the ancient public space.

This arena or stage still exists. In fact it is a bloody scene, the stage of massacres, ethnic cleansing. You cannot simply say the city is passé or the human body is passé. Torture and killing remain the most important medium for the human body. What I am saying is that this is a necessary agenda for Art. There is a growing number of projects that I really admire done by other artists right now on the internet (World Wide Web) which really are provoking or inspiring interaction and growing a kind of discourse. But what they don't propose is this bodily element; they don't connect electronic communication with the body and its experience, with direct contact. I'm not criticizing these projects. Actually I'm saying that the discursive aspect of my work is not so original because of this electronic work already done...

ROBBINS: But you were just saying that the body must continue to have a place in what we've been calling the public sphere, that bodiliness is something that can't be forgotten. And one thing people appreciate about your work is the way it refuses the idea that the true public sphere in our time is cyberspace.

WODICZKO: But I disagree with those who appreciate my work. Because their conservative reaction against cyberspace or the electronic public unnerves me. I think it is important to connect these different communicative situations and techniques in one work.

We know the incredible growth of the Internet and World-WideWeb also mimics dangerously the growing division between the poor and the rich, especially in the United States. This means a separation between the way populations communicate, hence a new form of alienation.

ROBBINS: Which it seems to me your objects are designed to frustrate.

WODICZKO: Yes. Well, a very modest attempt. But we need a more effective way.

XENOLOGY

ROBBINS: What about the Greek side? Xenology, and so on?

WODICZKO: The Greek side is definitely Socrates. It's all between Moses and Socrates. If this equipment seems to be prophetic, it's because it puts every immigrant, every operator in the role of a prophet, interrupting history to open up a vision of community. Each one brings their own experience, and in this experience is the seed of a new community. Of a world that would not ask the immigrant to integrate, but a world that would *dis*integrate, made of people who have disintegrated.

This connects with Socrates because Socrates did not tell people what to do. Socrates used an amazing discursive technique: he created situations in which people had to start thinking. What is Socratic about the staff is the position of the performer in what used to be called public space. Maybe a public place is being created in the very moment, the very act of performance or in the act of dwelling — the polis. Or, in Bataille's terms, a sacred place. Where people face each other's passions.

ROBBINS: Tell me a little bit about the science of xenology .

WODICZKO: By xenology I mean a field of knowledge which also connects with the field of experience. The field of historical intuition or present intuition. I want to propose an existential knowledge combined with life practice. A struggle of displacement. This has something to do with displacement.

ROBBINS: Not especially transnational displacement? It could as easily be an internal or domestic displacement?

WODICZKO: As inside of yourself.

ROBBINS: Strangers to ourselves, as Julia Kristeva says.

WODICZKO: Yes. This external *and* internal displacement is about crossing the boundaries inside of yourself. Because there are all those different borders one is discovering. Maybe they were there

before. But one recognizes this whole incredible world which is normally not recognized by people who stay in one place for too long. One can definitely learn a lot from strangers. Those who move less should listen very carefully to those who move more. And maybe the opposite. But the fact is that xenology would be experiential, theoretical, and artistic. In the further development of my project, xenology could be its aesthetic, not just its cultural or theoretical frame. The xenologist would be someone who is more aware of the field, a kind of prominent scholar or practitioner in the field. Like a doctor. A Talmudic doctor exists as long as Talmud exists. Here we are dealing with an oral history, not written texts. There are cases. Xenology is not centered around sacred literature, but it could assign to certain fragments of this historical material something like the meaning of a sacred text. Maybe it should be more displaced, not fixed in one body like the Torah.

ROBBINS: In your experiences of displacement, your wanderings, can you think of any discovery that might serve as an example of the sort of knowledge xenology would produce?

WODICZKO: I learned about xenology from a person whom I know well, Jagoda Przybylak. I would call her a xenologist. She runs a network of domestic labor for Polish immigrants. She cannot stop, cannot stop lending her experience, exchanging addresses, finding rooms for people, mediating. She spent so many years working and is still working today, despite the fact that she is teaching photography here and is an artist. She is still working in the field of undocumented labor, or half–documented labor, or labor in the process of being documented. This is a rescue mission, part of the Polish culture of resistance and survival. She is an ethical advisor to Polish people. They call her. And sometimes they leave messages on her answering machine. Recently she started to connect those messages. Now she has a bank of cases, messages left about miserable experiences or comical stories. She is working, so she's not home, but her answering machine is on. And people call, and they cannot stop. There is so much traffic of telephone calls that it is almost impossible to reach her. It is something for which she has not been paid or recognized. There are other people like her. She is not

alone. But I've learned that people like her are the most important figures in every country.

Jagoda needed the *Alien Staff* simply because she had never acknowledged to herself that her experience is something very valuable and something to be proud of. She told me at first that she didn't want to be a part of the project. It took one week of my persuasion. I would say, "why don't you try?" "No! I'm not going to speak about this! This is awful and in fact I don't even want to remember it." Or, "no, I don't even want anyone to know about this because there are all these people in Poland who need to know that immigrants succeed." And when they travel and they immigrate or when they stay, there's an incredible market for this imaginary relation to experience.

But she eventually started to search for relics. That was the first thing. She was interested to find a photograph of her nighttime cleaning colleagues at IBM. Just to find those great friends from Puerto Rico or from Poland. And she found it but then she had to travel across the whole city to find one of those friends. She of course took a camera, because she's a photographer. She discovered what had happened to this woman. Now there are eight people from Poland with her — actually six children — and something incredible developed around this person. She realized that there was so much to recover.

She started to write down her memories about a time when she was enslaved taking care of an elderly German woman who herself had been an immigrant to America fifty years before. It was a kind of revenge or compensation for her to enslave a completely new immigrant. So Jagoda started to write it down. This started to connect in her and finally led to videotaping and editing. It became several stories. One is called "Plejsy," another is called "Kompaniony," and another is called "Ofisy" — Greenpoint language for cleaning apartments, taking care of people, cleaning offices. Then this turned into shorter, more refined stories. And then more objects were found, usually so well hidden that she thought she could never find them. Because they were the most important objects that she had brought from Poland. And photographs and correspondence she received from someone in the immigration department. Finally she put all this together and she started to speak, with an incredible

ability to say things, and she grew to like it. She brought it to the airport and then wanted it back. She is always a consultant in the development of my projects. I cannot take any new steps without talking to her.

ROBBINS: I have a larger question about the politics of your work and its trajectory, about what the word "stranger" means to you. If one were unsympathetic, as I'm not, one could say that to focus on immigration is to forget all the people who have not immigrated — to privilege, as we say in our jargon, the metropolis as the center of the story, and to drop out all the people who have not left the countries that immigrants have come from. Is it to deal with an unhappy but somewhat privileged group?

WODICZKO: That brings us back to Benjamin and Levinas. To put emphasis on the stranger is to see ourselves, and to see ourselves as a democracy. It's the only way to know whether this democracy is human or ethical. We badly need strangers. We call ourselves a community, we claim openness, rights, and so on, but we have no way to see that community. So it must be interrupted by strangers (Benjamin), who are more important than we are. (I don't consider myself a stranger; though I am of strange origins, I have three passports.) For Levinas, the symmetry of democratic process can only be sustained by an asymmetry of ethics. If the stranger to the city and someone born in the city are equal, and democratic equality is guaranteed by human rights and by the constitution, our obligation is to challenge that symmetry, to open ourselves to those who are less capable of taking advantage of their rights. But it is we who are less capable of recognizing the needs of others, who do not fight for the rights of foreigners to vote. We impose taxation on everybody, but we don't demand that strangers have representation. They are living here, they have children, they have nothing to say about how their children will be educated, and so on. There is a myth of equality, a myth of symmetry between us and them, that needs to be challenged. To make that symmetry possible, one has to act asymmetrically. You have to overexpose people who are underexposed.

This is also an aesthetic effort. There's a need for a bandage to cover the wound. But something at the same time that helps people

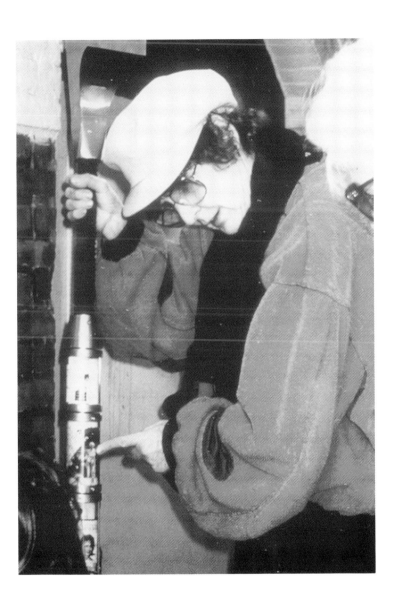

articulate, recognize the origins of the wound. Most of the designs I've made belong to this category of the bandage. The bandage also shows the location of the pain. It's in between, a communicative device. These instruments prove to be necessary, as the operators tell me. After they go through all the trouble of gathering information and opening it up to everybody, they report that they can manage their pain better. They can cope.

ROBBINS: Apropos of the bandage, one of the things I like so much about the *Mouthpiece,* your other instrument for immigrants, is the suggestion that it's a monstrous gag. While it's a prosthesis helping people express themselves, it's also expressing the impossibility of speech. It's a sort of bandage over the mouth, blown up to monstrous proportions.

WODICZKO: What I'm hoping to do with the new variant of the *Mouthpiece,* is a truly monstrous prosthesis, a cyborgian bandage that overemphasizes the need for equipment, for aid. It allows the mouth of the speaker to be both covered and uncovered. The monitor section of the equipment, showing the lips of the speaker, can now be shifted, so the operator can speak directly as well as with pre-recorded speech. Or it can be switched off.

ROBBINS: What kinds of changes in the *Alien Staff* do you have in mind?

WODICZKO: I'm interested to see to what degree instruments of this sort can be more playful. Inspire more of an artistic or baroque use. In other words, if they can respond better to the gestural and narrative virtuosity of strangers. Of course instruments of this kind are not for every stranger. Clearly they are for people who are more artists than others in their technology of survival, of insertion into the culture. They are for special agents—or angels.

ROBBINS: In ancient Greek angels meant messengers.

WODICZKO: Yes. Messengers who like to speak, who are angry enough, who are motivated. Sometimes even desperate. Or, say,

initially reluctant yet having an internal need to construct, reveal, or open up their experience and share it. It is very hard to describe the whole process in which people, once they learn about the possibility of this kind of project, select themselves to be part of it. But the person who chooses it is usually either the one who is in the worst trouble, or is in trouble, but not as much as he or she has been. They are people who want to be more public than they are despite the fact that what they say the so—called public doesn't want to hear. With the kind of equipment I am giving them at the moment, these people can do more than what they are expected to do.

But there is also possibility there. I am talking about an instrument that is not yet designed. I am designing a tool or instrument which will create a new situation. That level of the unknown is connected with a kind of intuition of the present, a revolutionary intuition of the present. There's an intuition that those people will be able, for example, to come to terms with their impossible set of experiences, the impossible reconfiguration of their identity or the new forms, new connections, inside of them. As they start recording and re—enacting their stories and reinterpreting, rhetorically articulating them in front of others, in interaction with the others, one hopes they will learn more about what they would like to say and also that they will learn to play with this somehow painful, difficult, and maybe tragi-comical device, enjoy it in some humorous and baroque or maybe even rococo way.

I emphasize the possibility of modulating the audio-visual recordings with gestures or even allowing the other people around to participate in this re-play or re-enactment. The Media Lab at MIT is continuing the project that was developed by Lev Sergeivitch Theremin, a Russian inventor, and recently rediscovered an instrument operated by gestures. It connects human electro-magnetic fields and the electro-magnetic fields which are electronically generated. I would like to test this gestural instrument. I have to build it to see how one could become a virtuoso of his or her own story, also maybe adding new components to the story, discovering more and more aspects of the experience and making it into of a more playful act of speech and also, psychologically, an act of self—construction. The playfulness is definitely a psychological need here, for

the operator and also for everybody else. In the space between strangers, and between strangers and non–strangers (if one can call them this way), this artifice which is already there as a kind of object could become more interactive and more interpretive or performative than it is now, I hope that it may be the birth of some other kind of instrument.

A PRACTICAL AESTHETICS

ROBBINS: Could you say something about the political uses you just mentioned— people who want to use instruments like this to represent others? Are there any examples that come to mind of people who want to use this technology less to speak about themselves than to speak on behalf of other people?

WODICZKO: Everyone starts with his own misery. But there's one person in a refugee camp in Poland, for example, who came from a very miserable situation in Morocco. He had lost contact with his family and he claimed, probably rightly, that if he returned to Morocco he would be prosecuted because of his anti–fundamentalist stance. So he contacted his family by phone. This is what he actually started with. But then he brought a seriously prepared speech to be recorded that was about fear, a problem he thought should be addressed. Such a large part of the population of this planet lives in fear. He had a theory of fear, which came out of his own experience, and he proposed the theory to Polish people. He speaks French. He got it translated from French into Polish. He asked Poland to recognize the need to help Morocco in this impossible situation where people live in fear. But he also asked the Poles to rethink the way they think about their own country and their own politics because of the danger of Catholic fundamentalism, which threatens to take over politics and eventually all human rights. Suddenly he was talking on behalf of Polish populations with which he had limited contact. But clearly he had picked up quite a lot about problems in Poland, maybe by listening to the radio or speaking to people. He knows Polish well enough.

Actually, when I think about it, everyone mixes politics in, connecting the personal and the political. But only on occasion does it

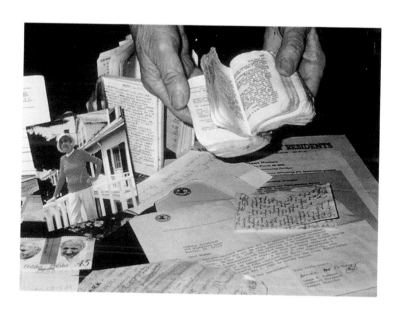

get dangerously close to using this equipment to address political issues more than their own experience. As Benjamin said, when you transpose the personal into the historical, that is what is revolutionary. They think this is the moment in which history has to be addressed. Because if one doesn't speak about it right now, things can irreversibly turn into catastrophe. Both in their lost land and in their promised land. This is how they are messengers.

ROBBINS: Could you say something about any of the reactions to the use of these instruments either that you've seen or that you've heard about from people who were using them?

WODICZKO: It has become clear that much more is happening with this stick than I anticipated. The reactions were usually good when there were both immigrant and non– immigrants around this stick. First of all, there was an attempt to exchange and share experience between the operator and other immigrants, maybe from other countries. There is usually very little connection between immigrants. And then there are the non– immigrants who, of course, might have imaginary relations to their memories of their own "first place." They might feel that in that sense everyone is an immigrant. Everyone feels strange, everyone is alienated. So what's the problem? But when they start getting into the details of the exchange of experience among immigrants, they realize that they are actually not part of the same conversation. They cannot be. They want to listen. Or, they want to speak more in order to dominate the discourse, to re–interpret the situation of immigrants for them. This was very apparent in France. There were some types who immediately translated fragments of what they heard into a kind of rough theory, making it an act of their own speech, political speech. "Let me tell you what you mean," and "what does it mean from the point of view of democracy in general?" All of those concepts like egalitarianism that they carry from the 18th century— they truly believe in them in France. But usually it is so ridiculous that they are overwhelmed by the reaction. Or there is silence. A very thorough kind of silence. They are trying to learn based on some sense of ideals or recognized ignorance.

There was one moment I found quite amusing. Conversation

developed so well between the immigrants around the stick that they forgot about it. They ended up in a restaurant and the stick was just leaning against the wall. One of the immigrants, from Morocco, was laid off. And as a result of this she got a job from the operator, who needed a baby–sitter. Later I took this as an important possibility for new equipment. There's something very pragmatic on occasion that comes out of all of the political and cultural debate, about national policy or legal problems they share, an exchange maybe of some addresses of lawyers, or god knows, some services. There is also the job market which appeared here. So I realized that in some next generation or network of instruments I should design in the legal and economic issues

The immigrant can become a "case." One could say, "Okay, actually this reminds me that I need to speak with someone because I don't know exactly what the situation is in terms of my legal status, which is changing all the time. And there are rumors. Is there any way I could find a job in this immediate situation? Is there anybody who could help me? Maybe *you* could help me." At that moment, the walking stick could become a transmitter of this question, and the operator could also receive additional training as a messenger, a more informed messenger. Because they have established trust, they have opened up a concrete case which is in itself public. The person thinks, "It is almost impossible that this person holding this staff would be an immigration agent." There's always this question — is she actually spying on us or trying to report us, our cases, to the immigration office? People who are completely fearful and paranoid will never accept the staff. But there are enough people who will suddenly realize, "No, this person is one of ours. So then she could transmit some problems, saying I'm not giving your name, this is not televised. I have a lawyer on-line." In fact there could be a legal station on-line. It could be transmitted very easily to a satellite and it could go to a computer run in the base of the staff which could very quickly identify all of the options for the stranger. But also the messenger could say, "Alright, this reminds me of somebody else in your situation." So something like this could be reported or transmitted and then encoded. The case could be re-tried and also transmitted back audio-visually if it's within, say, a 100 or 150 meter radius. There is no problem to

retransmit an image. Especially if you use a computer system, not video, not television, but a computer screen. There could be an actual person on the screen or it could be a document, a particular immigration form or some kind of formal petition for immigration. They could say, "Do you have this kind of document? Is this the way your visa looks?" So there's a possibility of a very concrete service.

WODICZKO: The equipment would have to be transformed in relation to the growth of this organization or network. I have no idea in what direction this would go in terms of the form of this equipment. I'm in touch right now with legal services in Cambridge who help with immigrants. This group of lawyers think it will be very helpful to have some agents or angels to encourage these displaced people to help — free help. If this works and the trust is built, if the immigrants are working with the lawyers, if there are some psychological cleanings, some neighborhood cleanings, it is possible that eventually this project will find some money if there is any hope to find money for any cultural projects. Or maybe cultural research grants. With the possibility of a larger group and a number of instruments and an electronic network, we'd have to really rethink the whole design part.

INOPERATIVE COMMUNITY

ROBBINS: When you were talking about the new computer technology that you'd like to experiment with, I wondered whether you had recording equipment as part of the *Staff*, as a way of making it more interactive, producing something that would include the people around. And then I thought that, practically, this seems like the worst idea in the world because of the fears people have that it would be used as an instrument of surveillance.

WODICZKO: Yes, even the idea that I presented is doubtful. How do you convince people that the possibility of digital transmission is really there and is not really a trick? How to open this up without scaring people to death? Another possibility would be to eliminate

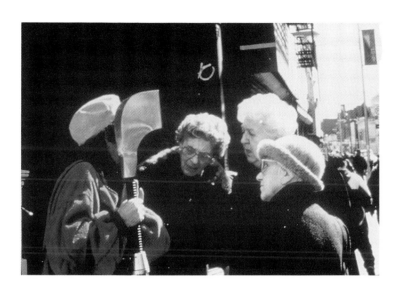

this transmission altogether and rely on live transmission, rely on the possibility of meeting the same person at the same time... The operator could reappear the same time the following week. That is what happened in Greenpoint, on a Sunday in front of a church. It is a very important place in Greenpoint because it's a church attended both by Poles and Puerto Ricans as well as some other groups, not as many Polish as maybe one would hope, but some. And it is a sacred place because they share the same religion. And a sacred place could be used as a site for this performance. And as I said, someone asked "Will you be here next weekend?" In this question there is the possibility of a community, a newly born community. It means I will give myself a week to figure out whether I should trust you enough to bring my uncle or my brother and tell you something and tell you something more. But now I will ask you a few questions. So I will ask you, "Will you be here next weekend? And by the way, do you know anyplace to go for help? Or in what way are you connected with, say, people who clean apartments or people who take care of elderly women or men, or who clean offices at night?" In this moment the operator will have to rethink whether this is actually a trustworthy person. Eventually by probing questions they will find each other.

Certain fragments of what Jean–Luc Nancy said about community seem strangely familiar when I observe what's happening around the stick. He proposed a different kind of community, and this helps me to understand my own work. He says that there is a kind of un–doing of community, an undoing of ties or pre–conceived notions of the commonality or communistic or communal. And this immigrant is refusing to accept any imposed notions, or ties, or connections with others. She's saying "No, no, I'm not part of it. Don't worry." Or, "Please do not think that we all have the same situation or that I speak here on behalf of others. No, this is a unique experience I am opening up. I don't know what others go through. Telling you all the complexity, all of the problems I have with myself, with the way I was and I am no longer, with the things that change in me, it is difficult to actually accept what I am doing. All of the questions, all of the disagreements inside of me, this is something that you have to listen to. Because this is something that I cannot even say without a certain hesitation and pain" I'd like to connect the *Staff* with this kind of community of un– working and un–doing, a community of refusing, of

refusal to be fused — I think that is what Nancy says, more or less — and yet also a possibility of community disseminated, contagiously spread by the immigrant, a community of all of those disagreements and problems inside of one person. The person will say, "Join me in this exploration and we will have in common all of our doubts about what is supposed to be our collective or community, what is supposed to be the legitimate bond between us. Let's replace it or let's drop it and talk about what is really happening inside of us and whether we can share it." In this way, I could see this stick as, maybe for a moment or fifteen minutes, the point of a birth of a new community. A community that comes from inside the containers, from all those things that are contained in the video and the relics, but also from the play with them. If I could make it more playful and interactive... Laughter —all the jokes, the disruptions, the changes of topics, all the absurdity and impossibility of talking about identity. This is the new community.

Maybe something else will come out of this. Maybe something with which Nancy will not agree. But it will also be connected with a kind of Brechtian interruption, with what Benjamin calls the "interruption of history." As I've mentioned on many other occasions, the interruptions of the linear continuity of the history of the victors by this secret tradition of the oppressed which is non–linear and always negative and always disruptive. And always trying to recover their own history. This concept of un-community or this community of refusal of being fused could be connected with this concept of interruption.

ROBBINS: Listening to you talk about Nancy and the notion of community, I thought that in a sense this is something you had already been thinking about from the moment you began playing on words with the *Polis Car.* On the one hand, noting the danger of surveillance, that is *police* car, and on the other, trying to revitalize the notion of the polis, the community. It also seems that you are not just now beginning to play with fear. Your consciousness of fear has always been part of the aesthetic element for you, maybe even part of the Brechtian *Verfremdung* you mention— your work shouldn't be too warm and cuddly, it shouldn't be too user–friendly. There should always be an element of fear as part of the experience. Or perhaps you feel that there is an element of fear, hostility, negative feeling, which is inextricably connected with the hope for the building of community?

WODICZKO: Yes. Because of the legitimacy of community. The community can only be legitimate when it questions its own legitimacy. This is certainly true in a so–called community of city inhabitants. New York as a community has to question itself immediately. "We New Yorkers." The homeless people can define what they mean by being New Yorkers, and this does not correspond to the others.

TIME, RHYTHM, MEMORY

WODICZKO: For many artists design is a difficult area. What is expected from "art" objects or "artistic" acts or actions? An artistic event is a translation of some set of internal or external issues into form. While in design, the situation is much more complex. It is a juxtaposition of connotation and denotation, the pragmatic and the symbolic, which demands acting, doing, operating, or experiencing. It has both practical and metaphoric aspects, it is feasible not only in objects but in the way one lives. It brings meaning to the idea of everyday life.

Of course this corresponds to a myth of Constructivist and Productivist art: a design of new rhythms of art, not a design of objects. Rhythm of life process— there's a lot of mystification there, and a lot of utopia, clearly. But it is important. The issue is not to be utopian. The issue is not to create better or new art but to create new life. That was the assumption behind productivism—it is not about production but about moving closer to life, impatiently. Not just waiting for an aesthetic practice to transform life later on, not injecting some essence, through art, which will then re–emerge in the next generation as new perception or new imagination. No, let's do it now! In that sense I think design is as much a natural extension of art as politics is a natural extension of ethics.

ROBBINS: I hope you know that you've been very important to theorists of space, people like Rosalyn Deutsche and Neil Smith, and they find that your work helps them think about space. Maybe it would also be interesting to think about you as working with time. You were talking about constructivism as a kind of experimentation with rhythms of life. The way that you use the ephemeral, the knowledge that such and such a projection will not last, won't be there, or the way you were just talking about the "same time next week" theory as

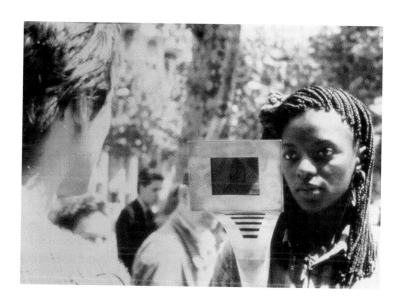

a possible way of mobilizing the Alien Staff— all of these things make me think that in some way you are doing a kind of art in time. That time is the material you are working with.

WODICZKO: Yes. It has something to do with the life of the city, inserting itself into the existing rhythms of life or ways of perception or interaction between different inhabitants, their relation to changing circumstances. What was good yesterday might be wrong today, and might be idiotic tomorrow. That's probably what Brecht believed. If one disrupts the routine perception of everyday life, one has to be tactical and temporary by principle. And that was definitely endorsed by the Situationists. This is not only the beautiful theory of everyday life presented first by Henri Lefebvre, but also an extremely humorous kind of Surrealist touch. Life is also a kind of popular art, living your patterns and enduring. The disruption of this everyday life makes perfect sense as an aesthetic project because the everyday is already an aesthetic project.

ROBBINS: Are you aware of being in dialogue with the perceptual rhythms of television advertising, to which you feel in some way you have to offer an alternative?

WODICZKO: I don't think they are necessarily my enemies. On occasion you see some level of risk and innovation and maybe meaningful disruption in advertising. I don't want to be kind of a straight moralist like many of my colleagues. I still have, even today, certain hopes that more intelligent and critical artists and designers working within the system might be able, if not to challenge the system, but to at least insert some degree of alertness into it. I would never really give up on extending critical strategies within the population of designers. We need some colleagues, some infiltrators, there. Some artists working in advertising leave and re–enter again, perverting or reversing its priorities, like Barbara Kruger. She began, as far as I know, as a designer. She was working initially as a part of the machine. Her work reintegrates itself with the advertising machine but without giving up the critical mission.

ROBBINS: Well, one of the reasons I asked you about time, and the

work it seemed to me that you are doing in the medium of time, on the materiality of time, is because I'm very curious about the extent to which the question of the public is a question of time as much as it is a question of space. We ask, "what's a public space?" but of course in this speeded–up, speed–it–up rhythm we all know, the public is also very much a question of time.

WODICZKO: I'll make this short. In France, when I started to discuss what benefits the Alien Staff could bring to immigrant populations, many of the activists and social workers told me it might be a necessary bridge between the new younger immigrants, people born of immigrant parents, who are still treated as immigrants in France, and their parents, from whom they are often alienated, and their parents' experience of crossing. Their parents are socially segregated, a population which it is hopeless to try to integrate—so the French say— so let's integrate the youth. The Alien Staff was understood as a possibility of a parent–children link that was something new. But this might require different equipment, or even a different cultural project than mine.

When Jagoda took the Alien Staff to the New York Institute of Technology, she decided bravely to present herself as an immigrant and not as a professor. And most of her students are Long Island children of immigrants. Somehow, electrified or hypnotized by her presence with this Alien Staff, they suddenly felt a desire to see their parents. They recognized something similar between her and their parents, something that they never really understood. Who are these immigrants? What are those silences? What does it mean? They learned from this so–called class. There's no definition of what it was. Was this a lecture? Was it a history lesson? Was it a media course or performance? I witnessed it because I had to help get her there. Some people started to take photographs, and it became a spectacle. The students completely changed their normal seating position in relation to her. They created a different space in the classroom. And she thinks that they respected her afterwards much more. Oral history, memory, the transmission of experience: these have something to do with time.

Bruce Robbins is the editor of *Social Text.*

PROSTITUTION NOTES

Suzanne Lacy

PREFACE: 1974

I decided to do a project on prostitution. I wondered who they were, these women whose lives were such powerful icons for my gender. How did I carry their condition inside my own experience?

I didn't want to put myself inside their shoes, walk the streets as an art performance, or dress up like a prostitute in order to flirt with their reality. I also didn't want to tell their individual stories, strictly speaking, except as their stories appeared along my journey. Rather, I thought to locate the work in my own experience, to record the process of my entry into an understanding of "The Life," as I looked for the echo of their situation inside my own.

I had no idea where to find prostitutes. I began simply by asking friends and acquaintances. I found that within the "field" of my intimate friends, there were those who had tricked themselves or knew firsthand someone who had. "The Life" wasn't far from mine.

I followed friends' leads and entered another world — one that lies just below the surface, if you know where to look. The street corners, restaurants, and bars of Los Angeles took on a new appearance.

MAY 9 LUNCH AT SARNO'S

I wonder how they live? Who supports them?

I meet Kristen Becker and her friend at Sarno's at 12:10. I have a salad and cappuccino (1968 prices before 5:00 pm), Sharon has one,

and Kristen has coffee. Kristen is running for city council on a prostitution ticket. She tells me she is not, however, a hooker, although she is organizing a branch of COYOTE (Call Off Your Old Tired Ethics) here in L.A. I show them some pics of my last performance, and Kris tells me she used to paint until her father fucked with her painting.

Would you know a hooker if you passed her on the street?

She tells me about her research — going to pross court Monday morning or sitting in a coffee shop near Santa Monica and Western boulevards to watch the whores. We talk about the Church of Naturalism, which is the organization for which they work, and they hasten to assure me they are interested not only in hookers but in old people and blacks and poor people and the mentally ill, etc. They are interested in massage and Feldenkrais and somatotypes and plants. In fact, it's hard to get them to talk about hookers.

HOW TO GET INTO "THE LIFE"

——> movement across surfaces
——> mental mapmaking
——> a destinational intent

MOVEMENT across large surfaces
as a function of life in L.A. (freeways)

MOVEMENT IS THE FORM OF "THE LIFE"

What is the form for this artwork? Is it a performance, a set of photographs, an installation? I am getting a sense the project may be about drawing maps, arranging appointments, scheduling time. My investigations have begun by tracking down people

Do you know on which corners you

can always find a hooker?

via my personal acquaintances, people connected in various ways with prostitution. Our meetings are over coffee or lunch. My appointment book is riddled with instructions for getting there, time, names, etc. I find myself wanting to record my journey, my questions, what I'm eating, collect matchbook covers, and draw diagrams.

MAY 14 CAPPUCCINO WITH MARGO IN SAN FRANCISCO

I have two cappuccinos at 4:00 pm with my students from the San Francisco Art Institute. We celebrate the last day of class. Also eat several Chinese fortune cookies and some Italian cookies. I call Margo St. James and arrange a meeting at Cafe Sport at 5:00 pm.

Do you feel loved when someone spends money on you?

Sit in Cafe Sport and wait to meet Margo, the exhooker who began COYOTE. Shouldn't have had the second cap. Very spacey, afraid I can't pull myself together to be coherent. I'm nervous, afraid of meeting a "super hooker." Realize my fear of being rejected by the "outsiders" with whom I identified.

What is my identification with hookers?

I wait for 45 minutes — drinking wine and soda to calm my nerves. I look up every time the door opens — finally Margo arrives and orders a cappuccino. I find her friendly and open but I still feel like a puppy. We talk about hookers. Then she says she has to go see a hooker that was busted on a set-up by the cops, one of whom gave her VD in the process. She says I can go along. She gulps down her cappuccino and away we dash to meet the hooker who is waiting for her in a bar.

151

THE FAST TRACK ———>
 "The Life" "The Game" "The Pimp-Ho Scene"
 A lot of fast talking and free movement———>
 WHERE ARE WE GOING?

Kitty is at the bar talking to some British guy. He wants a friend. He asks if I do the same thing Kitty does. He has very bad breath and tells me he makes a lot of money. I order a tonic and lime. I've had enough booze and coffee.

Have you ever bought a gift, hoping for sex in return?

Kitty works in a massage parlor, and when two or three gentlemen came in who turned out to be cops, she was busted. Now she's depressed: It was her first bust, and on top of that, she's got the clap. Should help her case. Margo is going to make a test case out of it. People in this game are always talking about cases and courts.

We drop off Margo's car; Kitty drives me to the airport. Kitty and Margo talk about a boyfriend who can only get it up with his wife whom he doesn't love, or some such thing. I use my illegal ticket, obtained from a friend's credit card and under someone else's name, to get a flight home. Fortunately they don't ask for ID. It blows my cover when they do.

Have you ever had sex out of a feeling of obligation?

Margo thinks that decriminalizing prostitution will be the largest blow to sexism yet struck. When women are free to sell and control their sex, then no negative image of whore can be held up to keep all of the other women "in line" — the negative, punishing image of prostitutes won't exist, she says.

JUNE 27 LOIS

I hear of Lois through a woman who heard her present a paper on pimp strategies at a sociology convention. I go to her house for a visit. She's very open and talks freely and fast. I am suspicious already of people I meet in this life. The principles of "The Game" itself make me question how their stories check out. I give Lois the "Deep Quiz." She offers readily: Her first lover, a black man, became a pimp while she was living with him.

I review my own life in terms of her story.

When she found out he was a pimp, she split, but still sees him occasionally and would like to get together with him when his story "checks out." She then met two men in a Mercedes at Los Angeles International Airport and they gave her and a girlfriend money for an apartment in Westwood. The men "kept" them for awhile. Pleading fear and innocence, she managed to never sleep with her benefactor once during the six months he supported her. When he thought she wanted too much money he dropped her, but in the meantime a friend showed her photo to a gentleman in D.C. who agreed to "keep" her. Over a several-month period she only saw him a few times: a night in Texas, a week in Georgia, and a day in Cuerna Vaca, where she told him to fuck off.

Have you bought your way out of something with sex?

She now works at a high-class nightclub while she does her research on pimping strategy for her master's thesis at UCLA. She obviously loves "The Life" and is caught up in its intrigues, battles of wit, gaming, and competition. She lives a double life, although her personal style, as a sociologist and "a player" is the same: aggressive, ambitious, and intelligent. I like her, suggest we work together. She agrees.

Has anyone you know ever turned a trick?

"SIGNIFICATIONS" FOR TRUST:
Direct, straightforward presentation of her story
 She is a student
 I see her paper on pimps
 I am in her home
 She is nondefensive
 She trusts and likes women

JUNE 29 – JULY 9 A TRIP TO MEXICO

BOOKS TO READ:
Pimp: Story of My Life (Beck)
Black Players (Milner)
Ladies of the Night (Hall)
Streetwalker (Anonymous)
To Beg I Am Ashamed (Cousins)
Brass Checks and Bright Lights (Mazulla)
Friends Lovers and Slaves (Stein)
Whoreson (Don Goines)

I reside for five days in a lovely room overlooking the ocean and eat in a nice restaurant also overlooking the ocean and I sit and read all day. I'm reading about "The Life" and

Did you ever wonder if you were desired for your money?

pimps and whores. The trip is paid for by my lover. I feel insecure with his paying. I can relax only if the economic support is clearly defined, i.e., "one trip," "a dinner," " a treat," etc.

I discover an aspect of my interest in prostitution is about my fear of taking money from men.

I am immersed in a completely new way of perceiving the world, and yet it is so familiar that it easily fits into my perceptions about the relationship between men and women. All Women are ho's (whores) and All Men are pimps or tricks, and sometimes are both. The pimp (blade) appeals to a woman's natural instincts. He accepts her "ho-nature." He gives her the guidance and control over her life she naturally needs. She tricks the white man for him. (Pimps seem to be often black in this world.) She exchanges sex for the trick's money. The pimp in turn "tricks" her. He exchanges *his* sex and illusions for *her* money. Everyone gets their sex and their illusion, except the pimp, who gets money, which is power.

I give my lover the books to read when he arrives. He experiences the same perceptual shift as I have. He starts gaming with me. After awhile it gets obnoxious, so I use various strategies to counter his pimp behavior.

THE LANGUAGE OF THE GAME:
Sex = exchange medium
Money = power in sex

JULY 12 SATURDAY LUNCH WITH THE GIRLS

Lois and Ann show me around and talk about being kept by older men. Connections in the form of the hustle: tickets for your mom in Vegas, who your next man could be. Lois and Ann are well dressed, jeweled, know the Beverly Hills scene well.

"No" is the most valuable word a woman in their business can know. Men don't want sex as much as the game, the pursuit, they say. As we drive around we talk about "the game" and how they could only love men who know it, but they'd like to work on their relationship to these men so that one day there would be no games.

156

How did it affect your sex?

Ann is in love with a musician. He accepts her older "friend" as necessary to support her in the style she'd like. He has his own style. Makes $40,000 a year, she speculates. Lois is involved with Bill, who is a new pimp. She's still trying to beat him. They play the game together. She explains to us in great detail how she catches him in his lies, elaborate strategies she sees through. I am aware of my own strategies, not admitted, and my reluctance to give them up, i.e., to "cop" to them with my lovers. Lois does not enjoy sex with the man who keeps her. It's the "five minute ordeal." She has to be "in love" to enjoy it. The man who keeps her is jealous, sees her three times a week. Would like to fuck each time but (1) he can't, and (2) she has him convinced that she has a "sexual hangup." He would like to believe it.

> MAPS:
> —> Define subjective distances
> —> Connections between points (in which "The Life" occurs)

> IF MOVEMENT IS THE FORM OF "THE LIFE,"
> PLACE IS THE LANGUAGE

Lunch at the Hyatt Regency. I have a shrimp salad. This is where many hookers and pimps hang out. Not this afternoon, however. Only one hooker in the coffee shop. Hookers are tolerated by the hotel, which is frequented by show-business types. Ann, who gets $800 a month from her seventy-year-old lover, says her mother doesn't want to know how she is making a living, but is happy to exploit her money and connections. They take me on a tour. Sunset at Highland is a very hot spot for hooking. I'm amazed, since I've passed it hundreds of time and only noticed the nearby high school. We pass a tall black working girl on the corner. It is the middle of the afternoon.

I begin to see the importance of knowing the places where "the game" is played.

Daniels' Coffee Shop is where transvestities, transexuals, and gay men hang out all night. Pimps wait for their ho's. Ann tells me about her latest strategies with her boyfriend and the man who keeps her.

On Sunset Boulevard we pass several massage parlors. A large black man wearing a blue open vest stands guard outside. A white woman in bright red shorts leaves one of the parlors and goes into a nearby liquor store.

Did you imagine that the whore enjoyed it?

Western Avenue and Santa Monica Boulevard is a prime area for streetwalking. My lover's optical film printing shop is near here. The dirt in Hollywood depresses her, Ann says.

JULY 14 PROSS COURT IN BEVERLY HILLS

Lois and I go to court in Beverly Hills where we meet Kristen and George who go there to watch the pross cases. We wait and I talk to George to find out more about the Church of Naturalism and Lois gets hustled by a lawyer who keeps walking by and taking her aside. I have a feeling of kinship with Lois. We naturally fall into gathering information which I know we will share later. George tells me how the court cases work. When a woman is first brought in she doesn't know "the language" or behavior of the court. She has frequently been entrapped by a cop who has solicited her and fucked her and who then arrests her. (He tells me several such incidents.) Cops aren't supposed to fuck the whores. They also can't entrap them. Legally, they must wait until a hooker solicits them. But in court it is their word against the woman's, and the cops know the language and behavior of the innocent. George feels this is simply learned behavior that the hookers don't get a chance to learn.

After a woman has been in court enough times, what she learns is the behavior of the guilty. So she is always found guilty. They reduce the charges to loitering,

Are you uncomfortable with what you think whores know about sex?

trespassing, etc. Get her to plead guilty and pay her fine and leave. Every once in a while she will get sent up to Sibyl Brand. Sibyl Brand, he says, was built on the money left to the county from a rich woman's will. The will specified the jail was to be a nonbarred, minimum security detention center. After she died, the county decided that her wishes weren't in keeping with the legal requirements for detention centers and they built a prison instead. Her lawyer has been in court for several years trying to get the money back. The dead woman appears to have been pimped by the county and her name is still on the monolithic tombstone in downtown Los Angeles.

> LANGUAGE OF THE INNOCENT—> Moral Rectitude
> LANGUAGE OF THE GUILTY—>Shame
> GO TO COURT—> Pay Your Dues to Society
> GO TO JAIL—>Rehabilitation

I give the deep quiz to George to find out what Church of Naturalism is. I drink an apple juice — very nice canteen here.

We go to lunch in nearby Beverly Hills. I have a spinach salad. We talk about the pimps hanging out near here in the evening. George is arguing about something or other — the innate weakness in women and prostitution, or some such. Just as he is about to launch into the old "Monkey Argument" (the natural order explanation of gender relationships), I interrupt to point it out to him. Lois picks up on the game, quickly reinforcing me with a parry that is at once flirtatious, witty, and ridiculing. He is disconcerted (Lois and I function well together) and finds it hard to regain his line of reasoning about female neurasthenia.

> PROSTITUTION—>
> An open acknowledgment of strategies
> Enjoyment of power in the game of sex—>
> WHERE DOES THE PAIN COME IN?

JULY 15 DINNER AT BRUNO'S

Tina works downtown in juvenile prevention. She has worked there for five years and her attitudes toward hookers have changed during that time. She grew up in Georgia in a straight family. Her mother didn't tell her about sex and she had (has) a hard time getting into it. She says she hated the prostitutes at first and then learned that in fact she resented what she thought was their sexual freedom, their ability to give their bodies to just anyone, while she had difficulty giving it to someone she loved. This is one of my own curiosities about prostitutes. Was there something wrong with me that I placed such a symbolic "load" on sex, that I couldn't have sex with just *anyone* as a casual act, like eating? Do people in and out of "The Life" have different definitions of sex? Was I being manipulated with a "Ho's Dream," to think that sex was something special, reserved for the man with whom I would form a committed, monogamous relationship?

> THE HO'S DREAM—>
> Promise of a monogamous relationship held out
> to manipulate a whore—>
> THE PIMP'S #1 STRATEGY

Tina is very interested in the young prostitutes that she works with. She says the pimps are brutal and beat the women. She tells me of two young women she knows who are pimps. She respects these women's intelligence. Both are gay and have a stable of young

Are you uncomfortable accepting money from a lover?

women who turn tricks and give them the $. We are both somehow pleased that these women are pimps. Tina says they don't use physical force on their hookers and seem to hold out the promise of monogamous love as a goal to motivate their ho's. Tina is not in "The Life" and I can see the absence of gaming in her personality. I like her a lot.

Just at the point I could admit to my manipulation of men, a wall.

I experience a sort of psychological "wall" when I feel I "should" admit to my feelings and yet can't. Can't bring myself to say out loud what I see in myself. I operate under a different set of rules: the code of psychological fair play. Once I perceive how I am manipulating someone to get what I want, I feel am "supposed" to cop to it, reveal my use, unconscious though it may have been, of strategy. An honest relationship shouldn't have secrets, should it? Women *shouldn't* manipulate men, and vice versa. Yet in "The Life" such manipulative strategies are considered the name of the game. No guilt.

JULY 20 A NIGHT OUT WITH THE BOYS

Brian and I dress up at my house. Brian is a friend who used to be a male prostitute — he fucked men. We're going out tonight to see the places, just below the surface of straight life in Los Angeles. We take off, me with lots of makeup and looking rather hard and ho-like. We drive to Selma Avenue and there Brian stands alone on a street corner. I lean against a church on the other side of the street watching, Brian certainly does outclass the other hookers on the street tonight, as he talks and gestures to men in slow-moving cars. I am aware of men driving by who think I am tricking. Curiously, I'm not afraid, maybe because Brian is there and knows this world well.

A guy parked in a car honks and motions me over. I ignore him and he comes over. This guy, Dino, asks if I'm tricking and says he can fix me up at the Beverly Hilton, where he works. I say I'm not but he doesn't quite believe me. I invite him to join Brian and me for coffee. We go to the Gold Cup and he tells us he is a high-class hooker, only works calls, makes one or two bills per eve. He also says he is straight. It is obvious he is bullshitting and trying to think of a way to hit on me. Dino leaves, leaving us with the bill. The Gold Cup is filled with gay men, TV's (transvestites), and an occasional woman hooker. They know and are protective of one another, although I don't sense any hostility toward me. It is impossible to drink the coffee or eat anything they serve — grilled cheese or

163

BLTs with fries. Brian points out the old men who cluster around the corner, hoping to blow a young boy who is down on his money and who needs a cup of coffee or a hamburger. He says you can often spot a hooker by her shoulder bag. Two men dressed very convincingly like women come in. One of the male hookers is feeling her (his) breast.

We go outside and stand looking at nude magazines at the newsstand on the corner of Highland Avenue and Hollywood Boulevard. Brian says this is a good pick-up spot. We go to the Spot Light Bar. Brian says this is sleazy lowlife hustling and he will take me to the class joints when we're dressed better. I walk behind him on The Boulevard and watch the older men turn and stare at him. At the newsstand I buy a *Playgirl Magazine* and an *Advocate* and a *Free Press,* for research.

JULY 23 MISCOMMUNICATIONS

UGH! Miscommunications and lateness and running around… Is this part of "The Life?" It's certainly part of mine.

I am late to meet Lois and when I arrive at the Rodeo Hotel Bar, my hair still wet, she isn't there. The men at the bar all look at me curiously and the desk clerk smirks condescendingly, or so it seems, when I ask for change for the phone. Since this is a well-known pross hangout, I wonder if they think I am one.

I can't find Lois' phone number in information — naturally she's not listed — so I drive by her house in Westwood on the way back to Venice to find my address book. At home I call her service and my service but there is no message. Finally I call the Rodeo Hotel and she has arrived. I leave to join her and Kris. This rather free and easy style with appointments is one I've begun to expect in "The Life." People say they'll show, and maybe they eventually do, but its not always when the appointment was. Things are more

casual. They travel within a surprisingly small world, given the size of Los Angeles, a village of sorts, where they know they will eventually "meet up" with each other. And if they don't, there's always another night. Not like me. I make appointments and try to keep them, and get upset when I don't. I try hard to make connections.

While we are drinking at the Rodeo Hotel, Lois' old lover shows up in a Panama hat with his new ho. Ah, intrigue. He has a tonic for 75 cents. Lots of black pimps and ho's at the bar, flashing. I have my first hot spinach salad. See a couple of whores go to men's rooms. Also overhear two men calling "Jeannie Baby!" on the phone next to me as I call Jim Woods to meet us.

What do you exchange for sex?

My friend Jim, a very large and very gay black man, was going to come out with Lois and me, so we wouldn't get "hit on" by all the pimps. We were planning to go to the Rainbow Room, where there is a heavy pimp scene. We start off for the club in separate cars and I have the wrong directions and get lost. Call Jim again at 11:30 pm. He is still at a meeting... So I decide to go home, chalking the whole evening up to a big, expensive 0: Parking .75, cover charge 2.50, salad 2.00, tonic 1.75. (I make $4.00 an hour as a part-time carpenter.)

AUG 27 PETER THE JOHN

On Sixth street in downtown Los Angeles two hookers, their backs to the bus bench. You can tell who they were by their stillness — a solitary, poised waiting. Both wear hats. Downtown is said to be the end of the line for pross.

I am aware of the communication system among men who seem to be able to find out where the whores are even in strange cities.

It's 10:00 pm. There are several motels here. Stopped to take my last slide of the neon signs and a man walks up to talk. He seems very open and friendly. He is from Florida, here on business. Sells motorcycle parts and drives a motorcycle. I mention there are hookers here, as an opening, and he says he knows, he has just been talking to one. I ask if he himself goes to hookers and he says once a month. We have a long conversation in which he asks: What kind of sex was I into, did I ever hook, would I let him take pictures of me? Interspersed with a pleasant and frank conversation in which he says he likes the looks on hookers' faces when they see the size of his dick, which is big around though not so long.

I ask him if he knew that some hookers disliked men, and he says vaguely, yeah, lots of them were bisexual and, not to be distracted, he asks me if I am. He confides he had had a homosexual experience once. He says that he doesn't want any of the black or Chicano women who are there tonight, but that he is looking for a white woman. I know this is a coded invitation. We are in a subtle language game, one I understand to be predicated on my volition, one not underscored with a threat of violence. Therefore, even though it is night and I am alone, I am not afraid to talk with him. I recommend the gay baths on Melrose that my friend Paul (Brian's lover) frequents. Thrust. Parry.

Have you ever been supported by a lover?

I ask why he goes to hookers and he says it is easy, uncomplicated. You can leave all the hassle afterward. Says he is twenty-eight, wouldn't mind getting married but his wife would have to like "swinging." He would prefer to marry a hooker because they are more mature, experienced, and outgoing. As we are talking several ho's walk by — cars are stopping everywhere, men follow hookers into rooms, some leave quickly, as if they can't agree on a price.

> VERBAL AND SPATIAL REALITY——>
> A language of physical spaces that exist just
> under veneer of "respectable" life

A code of sexual signification between
men and women that exists just under
the veneer of conversation

POSTSCRIPT: 1996

About a year after drafting these Notes I returned from a month-long workshop in San Francisco. My lover from that time (*A Trip to Mexico, June 29 – July 9*) confessed to me he had picked up a hooker in my absence. Out of curiosity. Although the incident caused me a good deal of pain, we didn't break up over it. He repeated it at least once that I know of in the eight years we were together. When we broke up in 1982, I left Los Angeles.

I worked with Lois (*Lois, June 27*) again after this project. In 1978 we did a post-screening critique of the movie *Hardcore* in Universal Studios. Seventy-five feminists discussed the movie and related issues of prostitution and violence, in front of live evening news cameras. Lois went on to found California Advocacy for Trollops (CAT), which she was planning when we first met. In 1978 I invited Margo St. James (*Cappucino with Margo, May 14*) to be a guest speaker in a project Leslie Labowitz and I were doing in Las Vegas. I heard last year that a mutual friend met her at a nightclub; she was back living in San Francisco.

Have you or your lover ever been to a whore?

Brian (*A Night Out With the Boys, July 20*) died of a drug overdose about two years after the evening we went out together. My best friend Paul, his lover, was heartbroken. Over the years when I visited Los Angeles I'd stay with Paul in his mansion up on Outpost Drive. Twenty years later he died of AIDS. He was most of what was left for me of my connection to Los Angeles. I rarely go back there now, but when I do I can't drive down Sunset or Santa Monica or Hollywood Boulevard without looking for the ho's mingling with the sightseers and shoppers.

-END

ILLUSTRATIONS

(Produced by Editions Les Maitres de Forme Contemporains, Brussels.)

Invisible Monument

15. Jochen Gerz. *It Was Easy #3*. 1988. 220 x 125 cm. mixed media. Photo Credit: Chr. Larrieu, Paris. Collection Anselm Dreher, Berlin.

16. Jochen Gerz. *Immobility*. 1989. 260 x 300 cm. Scanachrome. Photo Credit: Lallouz and Waterson Gallery, Montreal.

17. Jochen Gerz. *Your Art #5*. 1991. 150 x 120 cm. mixed media photograph. Photo courtesy of Crousel Gallery, Paris. Photo Credit: Ph. Chardon, Paris. Frac Champagne Ardennes Collection.

18. Jochen Gerz. 1926 *Stones. Monument Against Racism*. 1993. Saarbucker Schlossplatz. Photo Credit: Martin Blanke, HBK Saar.

Under Re-Construction: Architectures of Bodies INCorporated

19. Victoria Vesna. *Architectures of Bodies© INCorporated*. 1995. Photo Credit: Sky Berman.

20. Victoria Vesna. *Architectures of Bodies© INCorporated* (Home). 1995. Photo Credit: Sky Berman.

21. Victoria Vesna. *Architectures of Bodies© INCorporated* (Limbo INCorporated). 1995. Photo Credit: Sky Berman.

22. Victoria Vesna. *Architectures of Bodies© INCorporated* (Necropolis INCorporated). 1995. Photo Credit: Sky Berman.

23. Victoria Vesna. *Architectures of Bodies© INCorporated* (Showplace INCorporated). 1995. Photo Credit: Sky Berman.

24. Victoria Vesna. *Architectures of Bodies© INCorporated* (Bodies INCorporated). 1995. Photo Credit: Sky Berman.

Alien Staff

25. Krzysztof Wodiczko. *Drawing for Alien Staff*. Photo courtesy of the artist and Galerie Lelong, New York.

26. Krzysztof Wodiczko. *Alien Staff*. New York, 1993. Photo courtesy of the artist and Galerie Lelong, New York.

27. Krzysztof Wodiczko. *Alien Staff*. Brooklyn, New York, 1992. Photo courtesy of the artist and Galerie Lelong, New York.

28. Krzysztof Wodiczko. *Alien Staff* operated by Jagoda Przybylak. Brooklyn, New York, 1992-1993. Photo courtesy of the artist and Galerie Lelong, New York.

29. Krzysztof Wodiczko. *Alien Staff* operated by Dgenevou Samou. Barcelona, Spain, 1992. Photo courtesy of the artist and Galerie Lelong, New York.

Prostitution Notes

30. Suzanne Lacy. *Prostitution Notes*. Los Angeles, 1974. Photo courtesy of the artist.

31. Suzanne Lacy. *Prostitution Notes*. Los Angeles, 1974. Photo courtesy of the artist.

32. Suzanne Lacy. *Prostitution Notes.* Los Angeles, 1974. Photo courtesy of the artist.
33. Suzanne Lacy. *Prostitution Notes.* Los Angeles, 1974. Photo courtesy of the artist.
34. Suzanne Lacy. *Prostitution Notes.* Los Angeles, 1974. Photo courtesy of the artist.

CONTRIBUTORS

MARINA ABRAMOVIC

Marina Abramovic was born in Belgrade, former Yugoslavia. She lives in Amsterdam and Berlin. Currently she is a professor at the Hochschule fur Kunst in Harburg and the Academie des Beaux Arts in Paris. For the past twenty-five years Abramovic's career has been a personal investigation of physical limits and mental potential through the performance medium. Recent solo exhibitions include *Marina Abramovic, objects, performance, video, sound* (Kunsthallen Bradt Klaefabrik, Denmark; Villa Stuck, Munich; Musee d'Art Contemporain, Lyon; Museum of Modern Art, Oxford; Irish Museum of Modern Art, Dublin; and Sean Kelly Gallery, New York).

DENNIS ADAMS

Dennis Adams was born in Des Moines, Iowa. He lives in New York City. Since 1978, when he produced his first public work in ten windows on the outside of a city-owned parking garage in Manhattan, he has recontextualized photographic images in public spaces. His strategy has been to reveal glimpses of the political unconscious of the specific urban contexts in which his works are sited. To this end, he relays his photographic images through architectural displacements that catch the viewer off guard. Many of his interventions have taken on the identity of functional public amenities, such as bus shelters, selling kiosks, street signs, pissoirs, drinking fountains, etc. These "decoys" operate both as entry signs and as excessive display apparatuses that conceal, crop, and mirror the photographic images they exhibit.

In addition to producing numerous museum installations in the United States and Europe, Adams has made public projects for Graz (Austria); Antwerp, Brussels (Belgium); Montreal, Toronto (Canada); Newcastle (England); Marseille, Saint-Denis (France); Esslingen, Harburg, Munchen, Munster (Germany); Dordrecht, Hoorn, Polenburg, Zoetermeer (Holland); Jerusalem (Israel); Derry (Northern Ireland); Bilboa, Ubeda (Spain); Geneva (Switzerland); Boston, Miami, New York City, and Washington, DC (United States). Adams is currently working on public projects for Chicago, Copenhagen, and Frankfurt. In 1994, two separate retrospectives of his work were exhibited at the Museum van Hedengdaagse Kunst Antwerpen and the Contemporary Arts Museum in Houston. Adams is a professor at the Massachusetts Institute of Technology, Cambridge.

JOCHEN GERZ

Jochen Gerz was born in Berlin and has been living in Paris since 1966. He has lived in Cologne, Basel, and London and studied literature, sinology, and prehistory. He has taught at the Art Academy HGB of Leipzig. Gerz has worked in the public realm since 1967 and has incorporated photogra-

phy and text in his work since 1969. In 1971 Gerz began experimenting with installation, performance, and video work. Recent works in public space include: *Monument Against Fascism* (Esther and Jochen Gerz), Harburg, 1986 (publication Stuttgart: Cantz/Hatje Verlag, 1994); *Monument Against Racism,* Saarbrucken, 1993 (publication Stuttgart: Cantz/Hatje Verlag, Stuttgart 1993); *Sine Sonno Nihil/The Bremen Questionnaire,* Bremen, 1995 (publication Stuttgart: Cantz/Hatje Verlag, Stuttgart 1995); *The Plural Sculpture,* Website Internet, Ada Web, New York, 1995; *The Dispersal of Seeds, the Collection of Ashes* (Esther and Jochen Gerz), UN Park, Geneva, 1995. Recent catalogues include: *Life After Humanism,* Neues Museum Weserburg, Bremen; Badischer Kunstverein, Karlsruhe; Cornerhouse, Manchester; Saarlandmuseum Saarbrucken; Staatliches Lindenau Museum, Altenburg; Altes Rathaus, Potsdam. *Les Images,* Musee d'Art Moderne et Contemporain, Strasbourg; *People Speak,* Vancouver Art Gallery, Newport Harbor Art Museum; Neuberger Art Museum, Purchase NY; Winnipeg Art Gallery; *Self-Portrait,* Tel-Aviv University Art Gallery.

SUZANNE LACY

Suzanne Lacy is an internationally known conceptual/performance artist whose work includes large-scale performances on social themes and urban issues. Her best known work to date is *The Crystal Quilt* (Minneapolis, 1987), a performance with 430 older women, broadcast live on public television. Most recently, she created *Full Circle* (1993), for Culture in Action, a Chicago sculpture exhibit curated by Mary Jane Jacob; *Auto: On the Edge of Time* (1993–95) an installation on domestic violence for Art Park and the Public Art Fund; and *The Roof Is on Fire* (1994), a multimedia public conversation and performance with two hundred Oakland teenagers, sponsored by California College of Arts and Crafts, the Oakland Unified School District, and KRON Channel 4. She is a proponent of activism, audience engagement, and artists' roles in shaping the public agenda. Lacy has published articles on public theory in *Performing Art Journal, MS. Magazine, Art Journal, High Performance,* and the *Public Art Review,* among others. She has exhibited in the Museum of Contemporary Art in London, the Museum of Modern Art in San Francisco, and the New Museum in New York, and her work has been reviewed in *Artforum, The Drama Review, Art in America, High Performance,* the *L.A. Times, Village Voice,* and numerous books. She has held fellowships from the Guggenheim Foundation, Arts International, the Lila Wallace Reader's Digest Fund, and the National Endowment for the Arts. Lacy teaches new genre art at the California College of Arts and Crafts and is Dean of the School of Fine Art. She is currently planning a curriculum on visual/public art with Judy Baca at California State University at Monterey Bay. Her book on new genre public art, *Mapping the Terrain* (1995), is published by Bay Press.

ANNA NOVAKOV

Anna Novakov teaches Art History, Theory, and Criticism at the San Francisco Art Institute. She holds a PhD from New York University in the area of twentieth-century art, with a specialization in contemporary public art. She also holds degrees in Art History and Literature from the University of California and the Université de Paris. She is a regular contributor to *Art Press, Public Art Review, Sculpture,* and other national and international publications. She has contributed essays to museum and gallery exhibition catalogs and has written extensively about issues of gender, public art, and contemporary installation art. Recent publications include *Language as Cultural Transition* (1995), *A Woman's Common Sense Medical Advisor* (1995), *Positioning: Text and the Voice of Authority* (1995), and *Markers: The Gender of Urban Space* (1994), a dialogue-based project in collaboration with New York artist Dennis Adams.

VICTORIA VESNA

Victoria Vesna is an installation and performance artist working with new technologies. She has exhibited internationally at a number of shows including the *Venice Biennale* (1986), the *P.S.1 Museum, NY* (1989), the *Long Beach Museum* (1993), where she served as media council chair and member of Board of Directors, the *Ernst Museum of Budapest* (1994), and *The Huntington Beach Art Center* (1995), *Virtual Concrete,* rapidly mutating into *Bodies©INCorporated.* Her research involves the exploration of 3-D space and questioning the dichotomy between the virtual and tactile worlds.

Currently she teaches *Electronic Intermedia* at UC Santa Barbara and has been instrumental in fostering an interdisciplinary collaboration between the College of Engineering and Art Studio. Victoria has received numerous grants and sponsorships from various industries and educational foundations including, Wavefront/Alias, GTE Outreach, and ICA (where she serves as online editor and a member of the policy board).

Vesna holds *f-e-mail* workshops designed to introduce women to the Internet. She is producing several CD-ROM/World Wide Web projects: *Computers and the Intuitive Edge* and *History of Art and Computing,* and *Life in the Universe* with Stephen Hawking.

Recently she presented work at *ISEA '95* and organized panels for a number of conferences including *Social Theory, Politics and the Arts* and *L.A. Freewaves.* She is currently involved in organizing *Terminals: Considering the End,* an online visual event (UC-wide) that will complement *Terminals: The Cultural Production of Death,* a conference that took place at UC Santa Barbara in 1996.

KRZYSZTOF WODICZKO

Krzysztof Wodiczko was born in Warsaw, Poland. He moved to Canada in 1977 and to New York City in 1983. Recent solo exhibitions include the Galerie Gabrielle Maubrie, Paris; the Fundacio Antoni Tapies, Barcelona; Josh Baer Gallery, New York; Wadsworth Atheneum, Hartford; Kunstgewerbeschule, Vienna; Hirshhorn Museum and Sculpture Garden,

gewerbeschule, Vienna; Hirshhorn Museum and Sculpture Garden, Washington, DC. Recent public projects include *Alien Staff* prototypes, Barcelona; *Polis Car* prototype, Manhattan; Public Projections, Newcastle upon Tyne, England; Zion Square, Jerusalem; Potsdammer Platz, West Berlin and many others. Wodiczko is a professor at the Massachusetts Institute of Technology, Cambridge.

San Francisco Art Institute
Board of Trustees

1996–97

Beverly James: *Chair*
Agnes Bourne: *Vice-Chair*
David Coulter: *Vice-Chair*
Christian Erdman: *Vice-Chair*
Ellen Klutznick: *Vice-Chair*
Jay Pidto: *Treasurer*
Mildred Howard: *Secretary*

Paule Anglim
Steve Anker
Nancy Boas
Agnes Bourne
Francy Caprino
Enrique Chagoya
Ian Yi-Yuan Chiang
David Coulter
Christian Erdman
Gary Garrels
Marcia Grand
Marion Greene
Mike Henderson
Tom Holland
Mildred Howard
Beverly James
David Kaplan
Betty Klausner
Gordon Kluge
Ellen Klutznick, Psy. D.
Charles LaFollette
Tapan Munroe

Tom Noonan
Harry S. Parker III
Jay Pidto
Lucinda Reinold
Sanford Robertson
Waldemar Rojas
John Sanger
Jack Schafer
Catherine Schear-Newman
Richard Shaw
Paul Stein
Gordon Swanson
Laura Smith Sweeney
Lydia M. Titcomb
Josefa Vaughn
Victor Mario Zaballa
Anthony Zanze
Emeritus Trustees:
Gardiner Hempel
Elaine Magnin
Margaret Olwell
William Zellerbach